TATTOO U

TATTOO U

 DESIGNS FOR ANYWHERE ON YOUR BODY

COMPILED BY
MICHAEL RIVILIS

STERLING INNOVATION
An imprint of Sterling Publishing Co., Inc.

New York / London
www.sterlingpublishing.com

STERLING, the Sterling logo, STERLING INNOVATION, and the Sterling Innovation logo are registered trademarks of Sterling Publishing Co., Inc.

Library of Congress Cataloging-in-Publication Data Available

4 6 8 10 9 7 5 3

Published by Sterling Publishing Co., Inc.
387 Park Avenue South, New York, NY 10016

© 2009 by Sterling Publishing Co., Inc.

Distributed in Canada by Sterling Publishing
c/o Canadian Manda Group, 165 Dufferin Street
Toronto, Ontario, Canada M6K 3H6
Distributed in the United Kingdom by GMC Distribution Services
Castle Place, 166 High Street, Lewes, East Sussex, England BN7 1XU
Distributed in Australia by Capricorn Link (Australia) Pty. Ltd.
P.O. Box 704, Windsor, NSW 2756, Australia

Printed in China 01/12
All rights reserved.

Sterling ISBN 978-1-4027-6243-7

For information about custom editions, special sales, premium and
corporate purchases, please contact Sterling Special Sales Department
at 800-805-5489 or specialsales@sterlingpublishing.com.

Contents

Introduction

"The world is divided into two kinds of people: those who have tattoos, and those who are afraid of people with tattoos."
—Unknown

The history of tattoo art is an ancient one that traces its roots as far back as 5,000 years ago. Tattooing has been practiced worldwide since at least Neolithic times, and it is an art that continues to evolve as time passes.

Today, the reasons people decide to get tattoos are as diverse as the people who have them. If you've ever thought about going under the tattoo gun but were unsure of what design to get, this book contains more than 500 tattoo patterns, ranging from simple letters to intricate tribal symbols. Use these pages as your guide to discovering beautiful and interesting tattoo designs for any part of your body.

Tribal Symbols

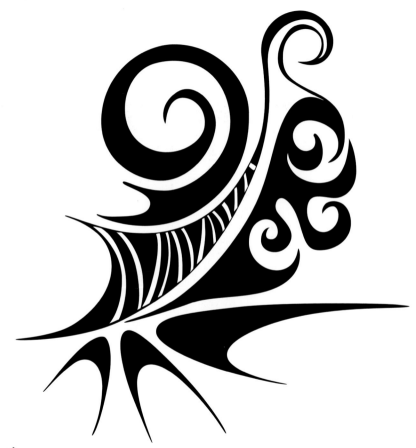

2 · Tattoo U

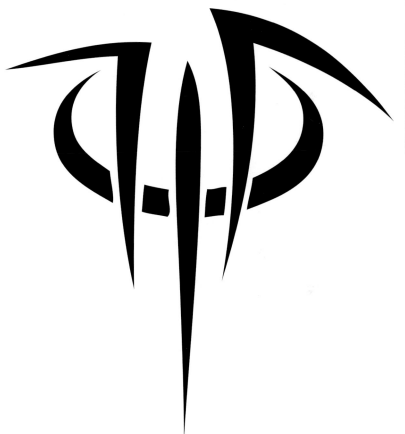

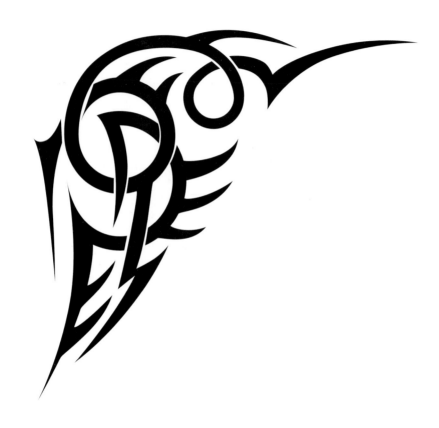

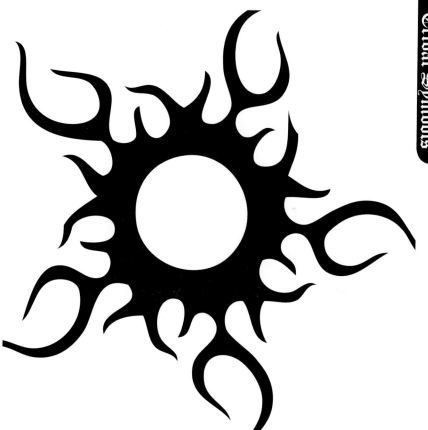

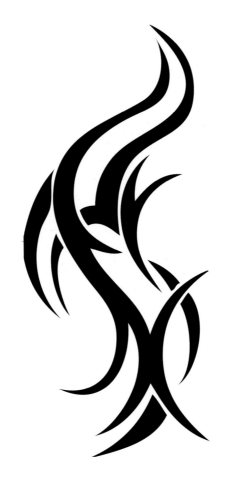

6 · Tattoo U

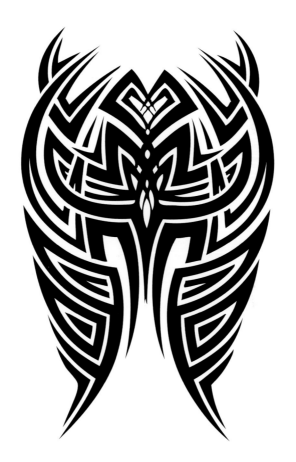

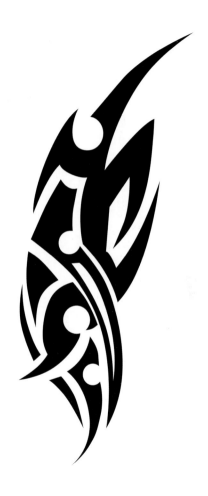

8 · Tattoo U

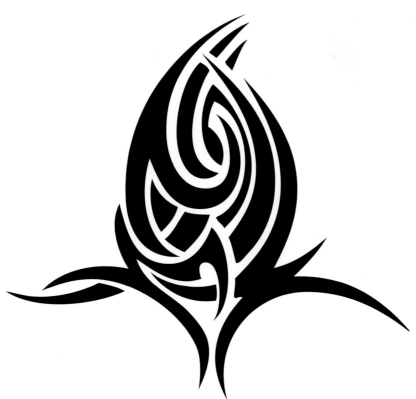

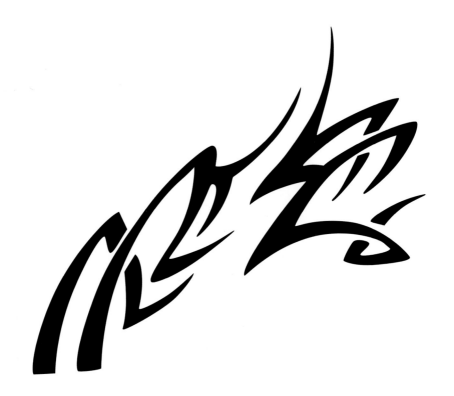

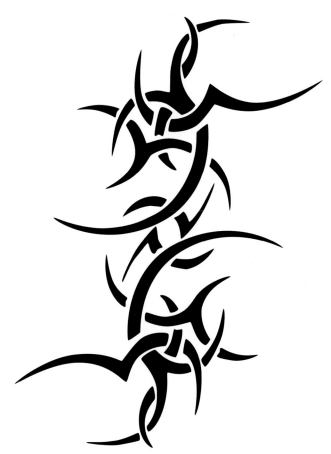

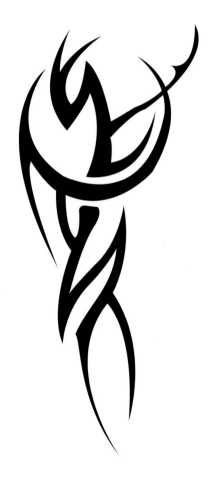

12 · Tattoo U

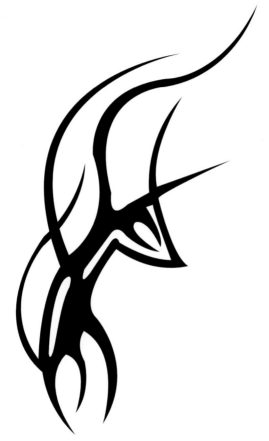

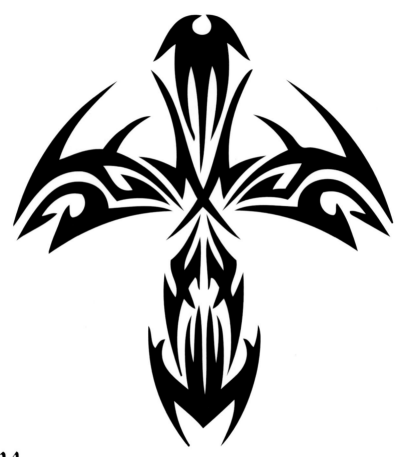

14 · Tattoo U

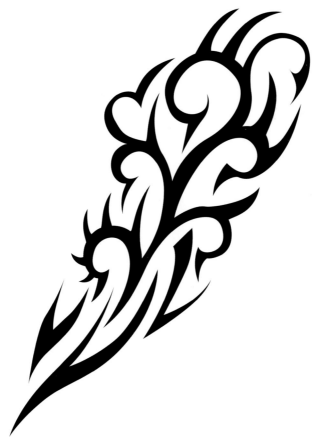

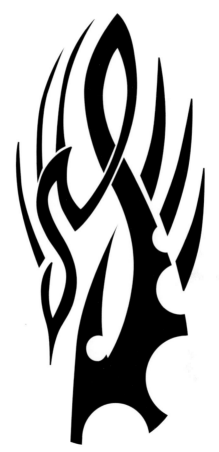

16 · Tattoo U

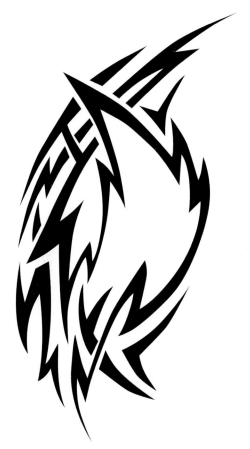

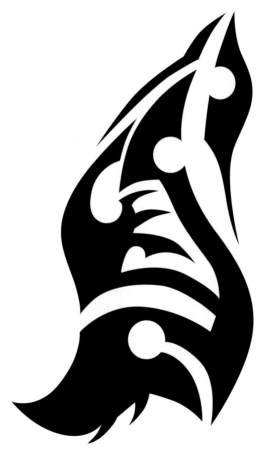

18 · Tattoo U

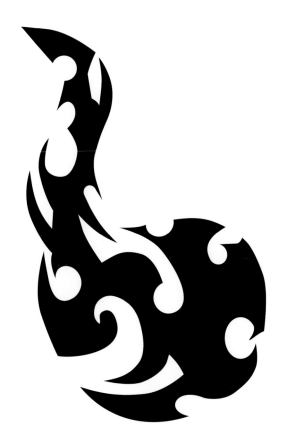

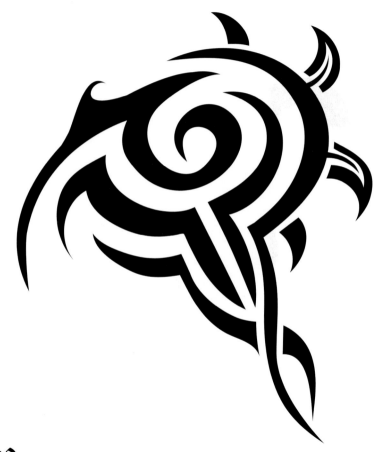

20 · Tattoo U

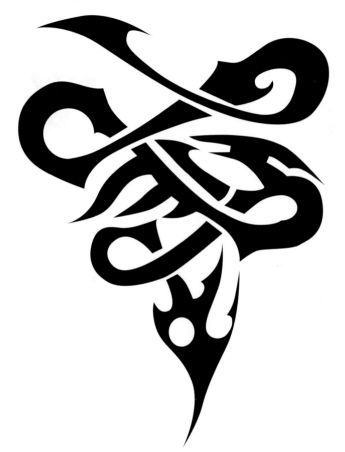

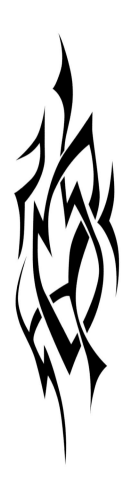

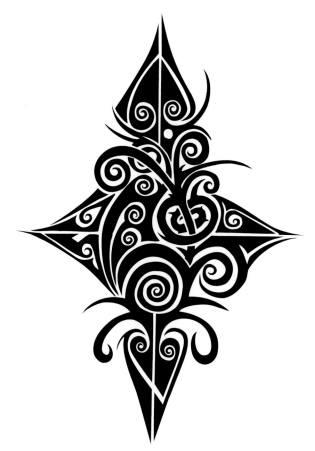

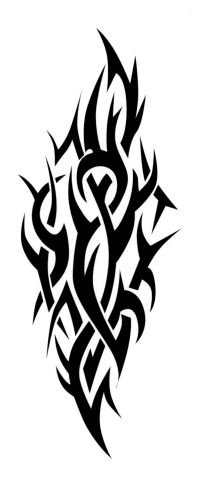

24 · Tattoo U

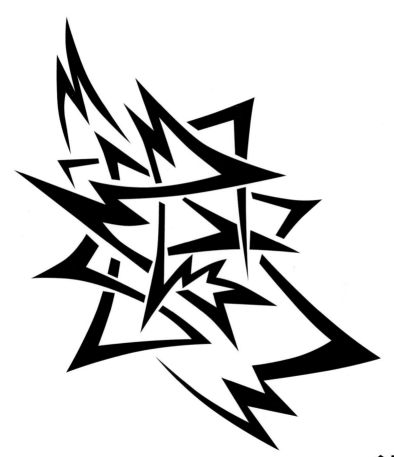

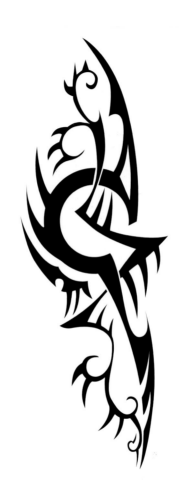

26 · Tattoo U

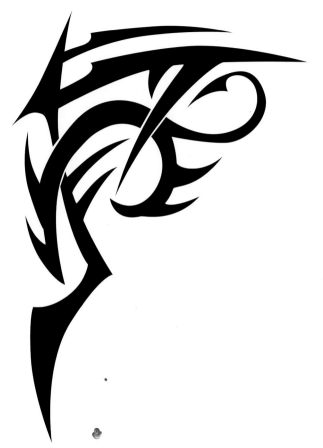

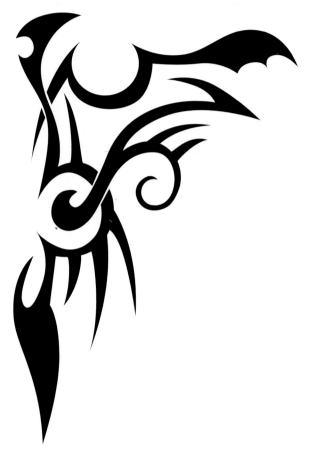

28 · Tattoo U

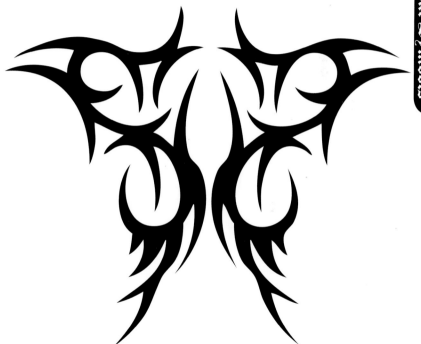

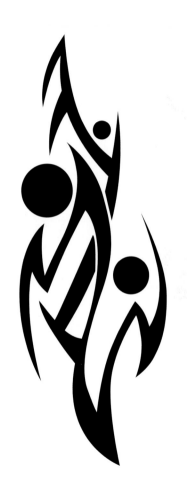

30 · Tattoo U

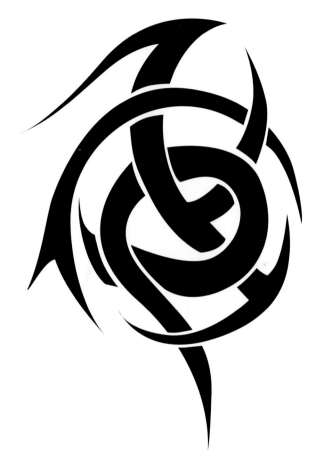

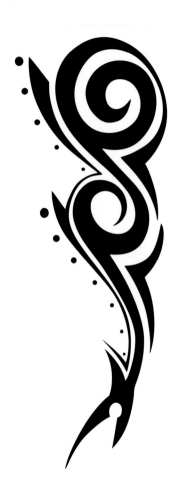

32 • Tattoo U

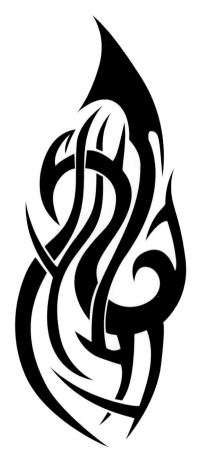

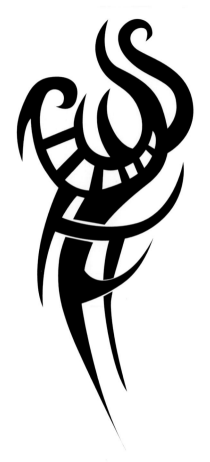

34 · Tattoo U

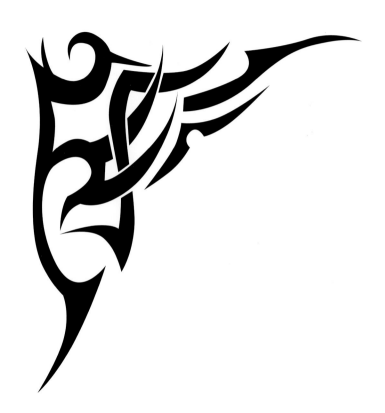

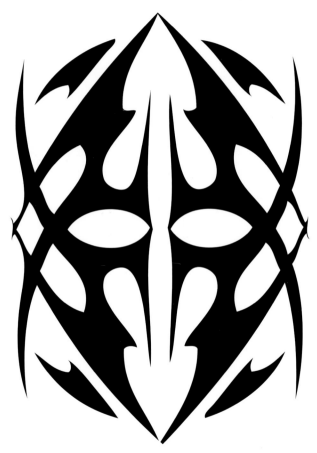

36 · Tattoo U

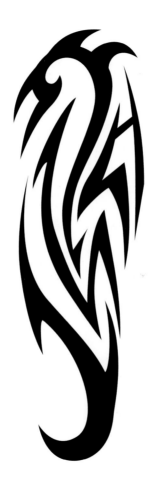

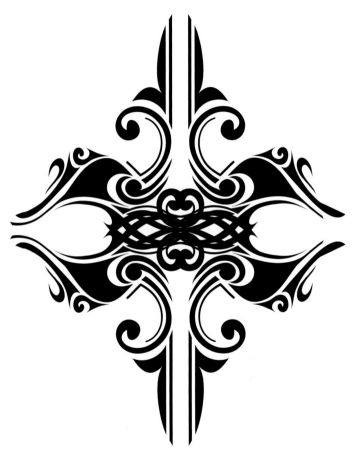

38 · Tattoo U

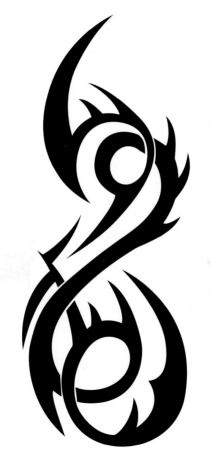

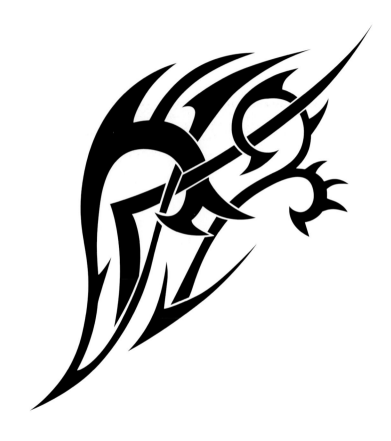

40 · Tattoo U

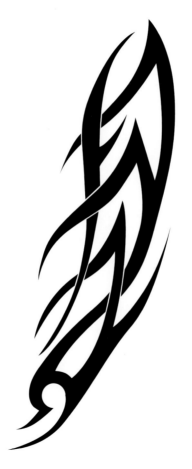

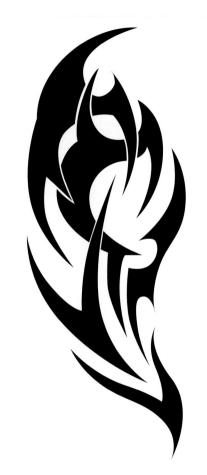

42 · Tattoo U

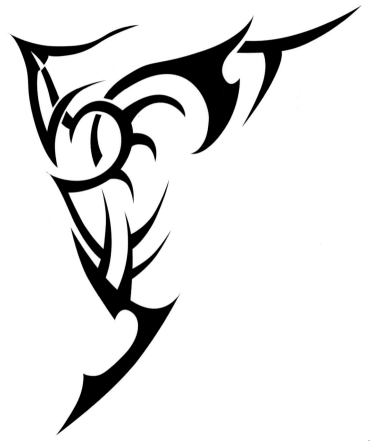

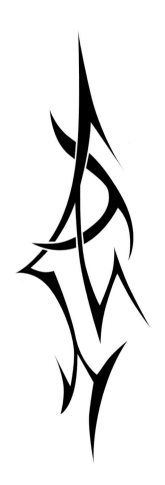

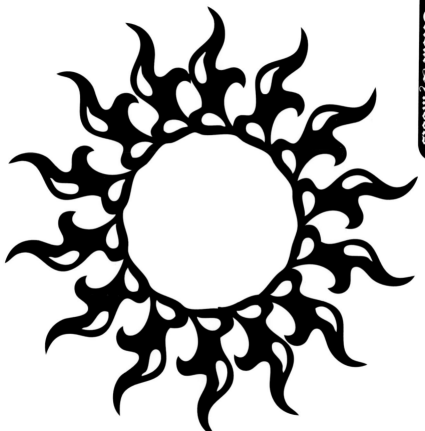

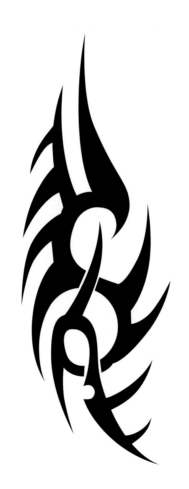

46 · Tattoo U

Celtic Symbols

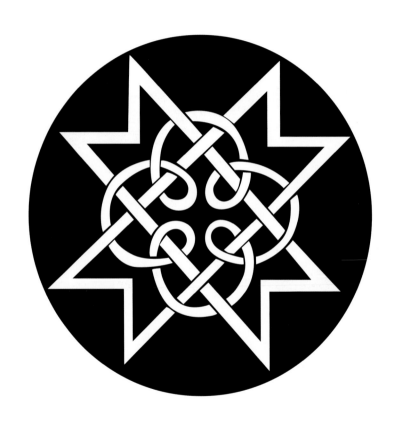

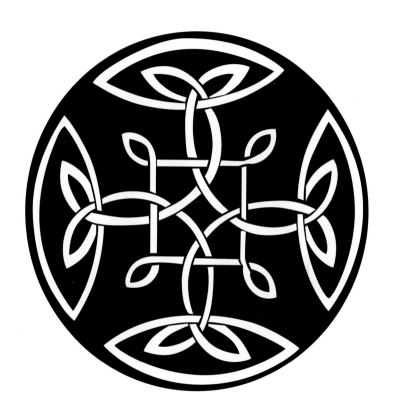

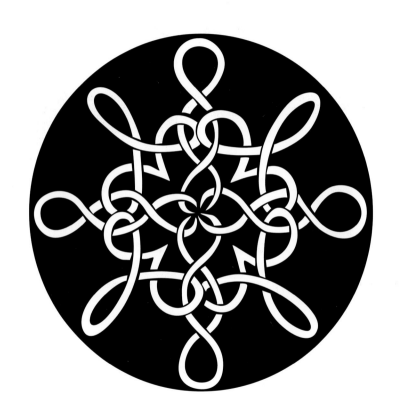

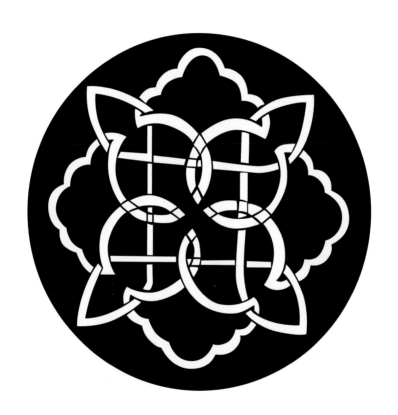

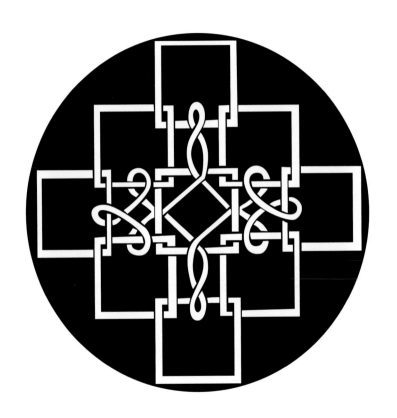

52 · Tattoo U

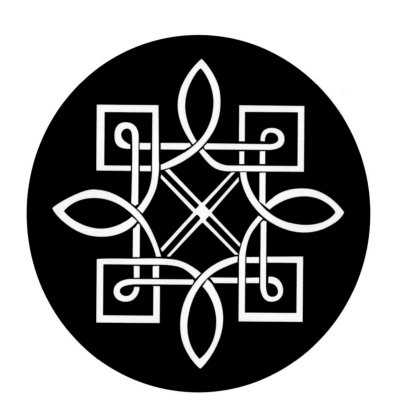

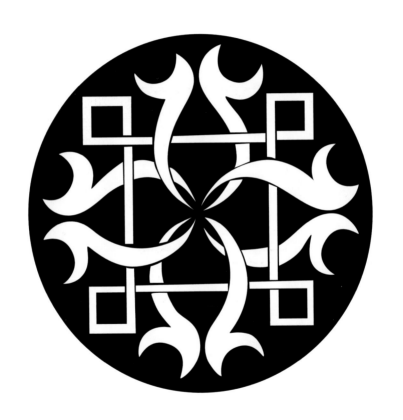

54 · Tattoo U

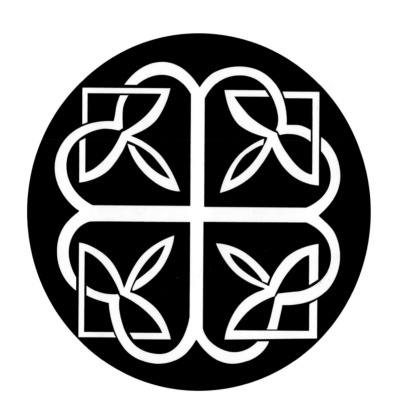

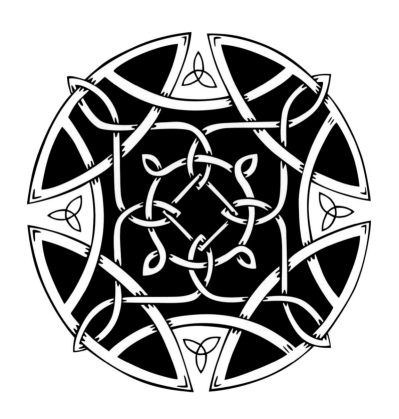

56 · Tattoo U

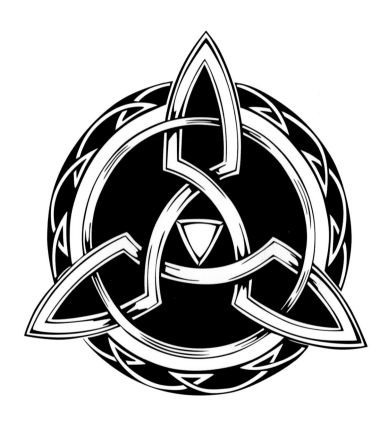

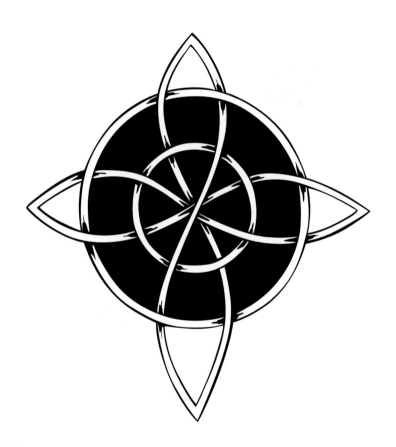

58 · Tattoo U

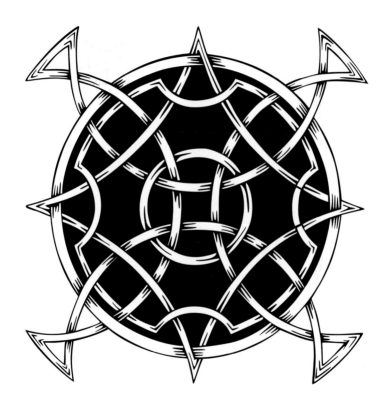

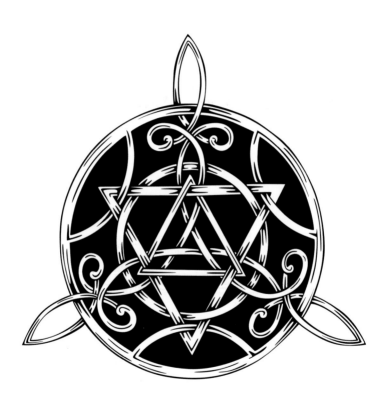

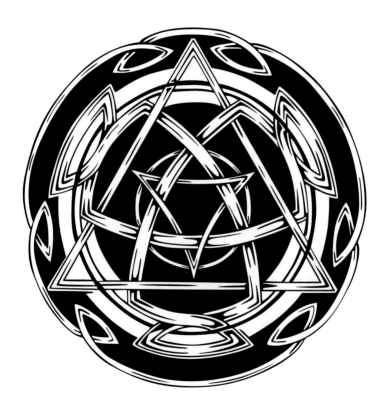

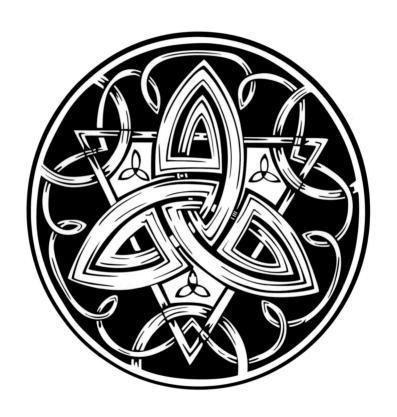

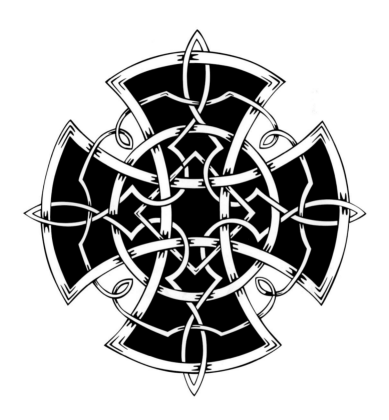

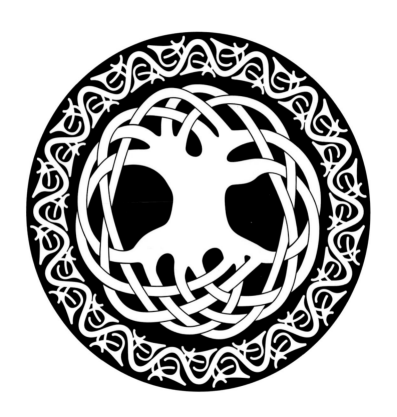

64 · Tattoo U

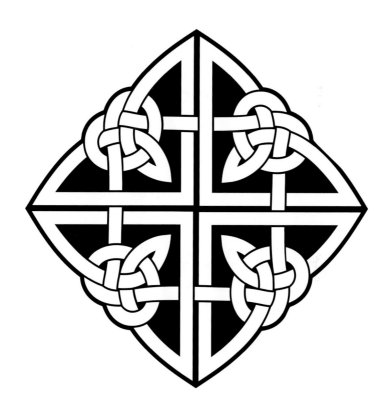

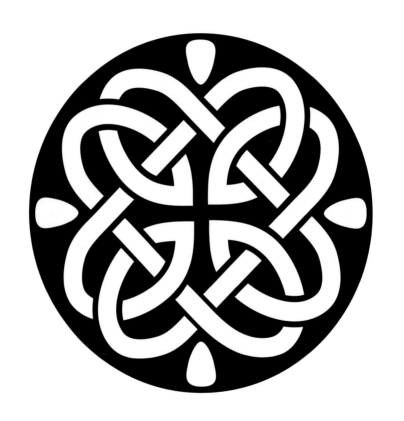

66 · Tattoo U

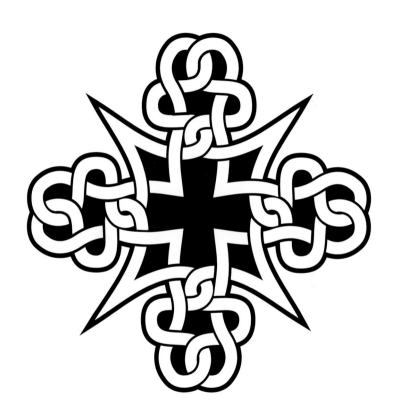

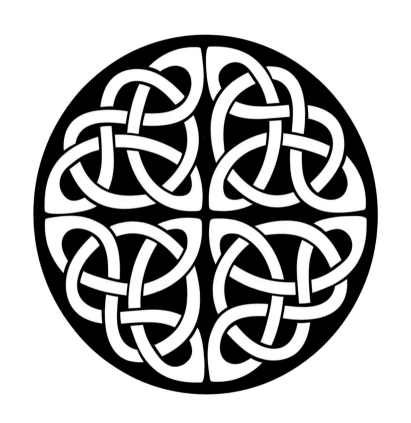

68 · Tattoo U

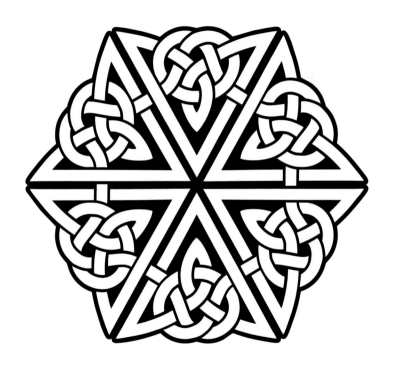

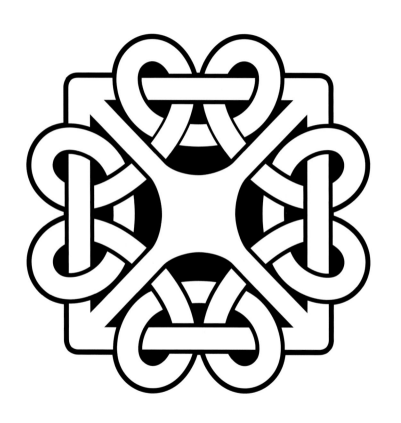

70 • Tattoo U

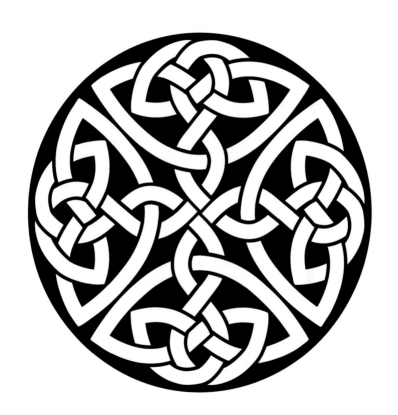

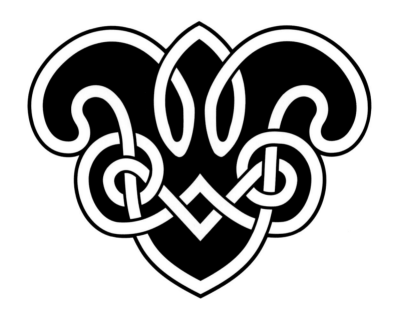

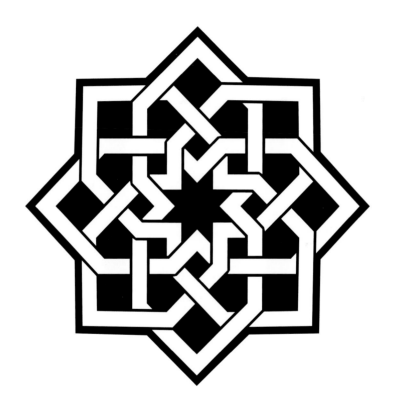

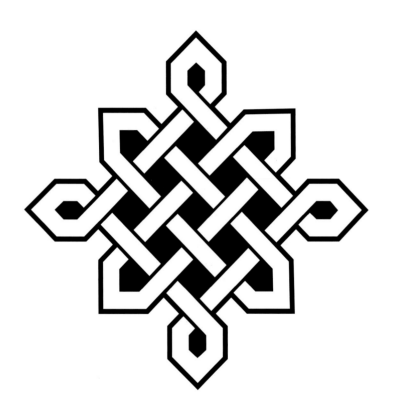

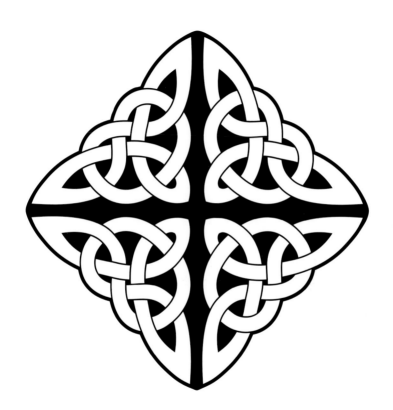

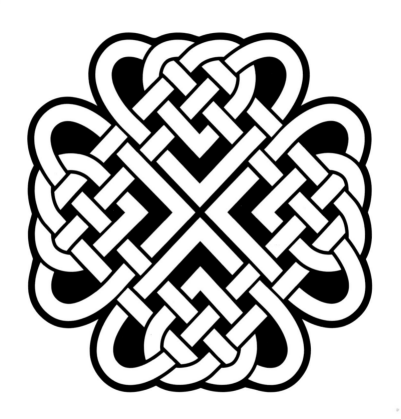

76 · Tattoo U

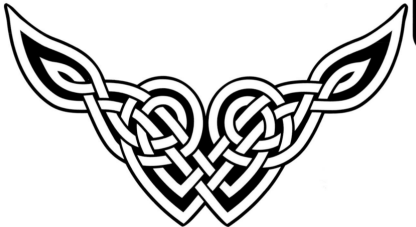

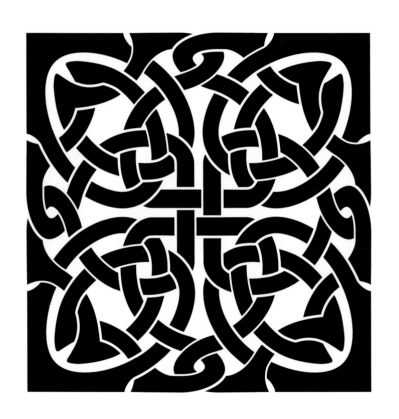

78 · Tattoo U

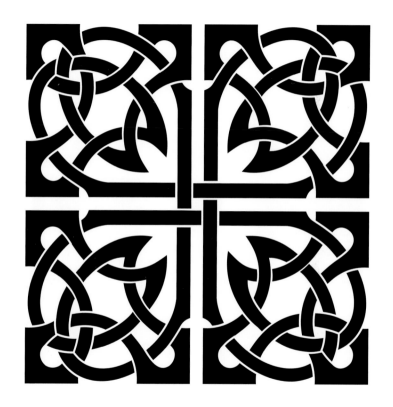

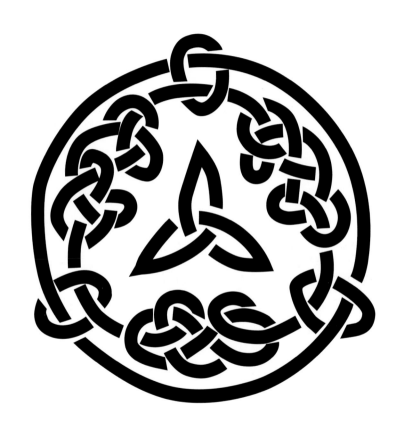

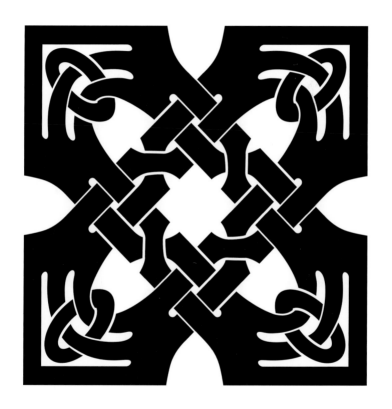

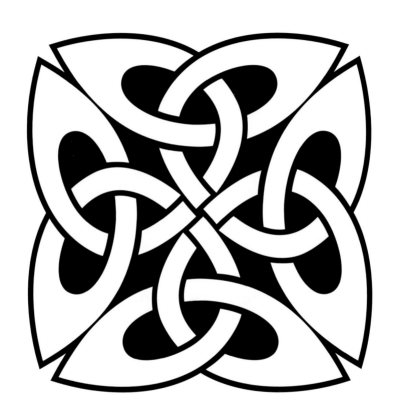

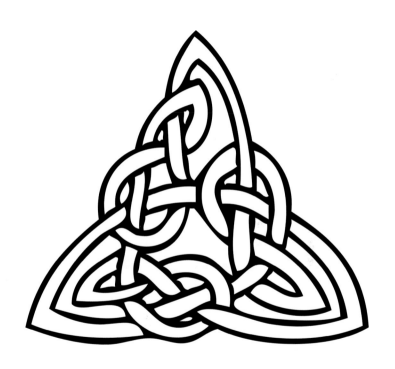

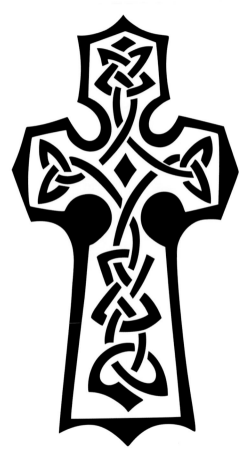

84 · Tattoo U

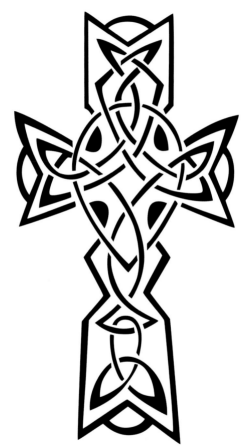

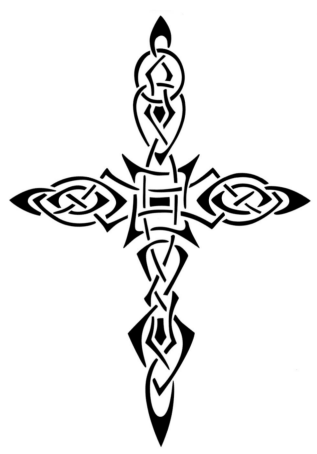

86 • Tattoo U

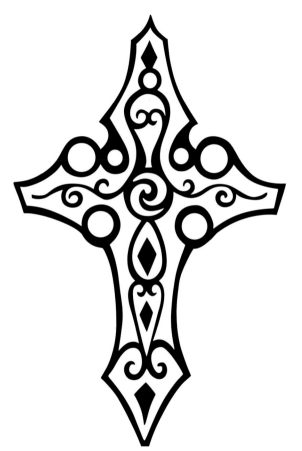

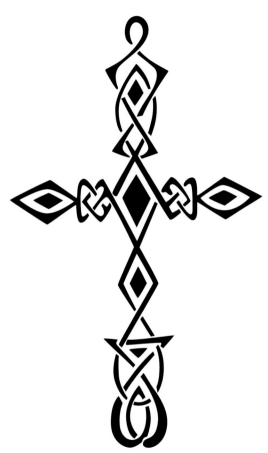

88 • Tattoo U

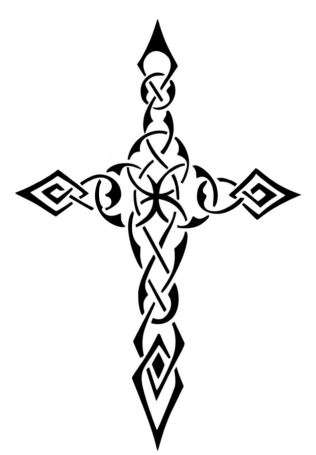

90 · Tattoo U

Animals

98 • Tattoo U

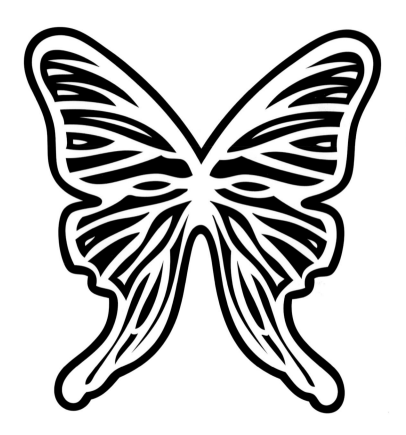

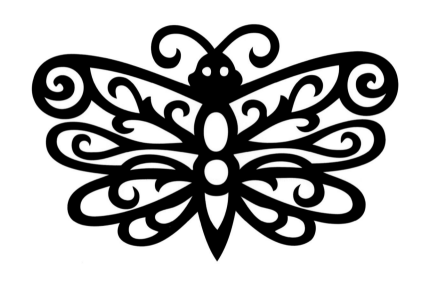

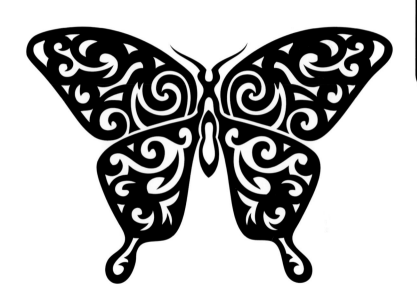

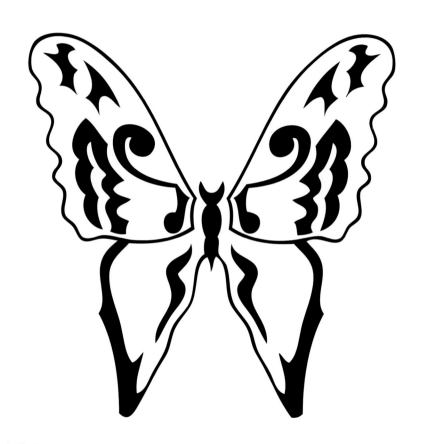

102 · Tattoo U

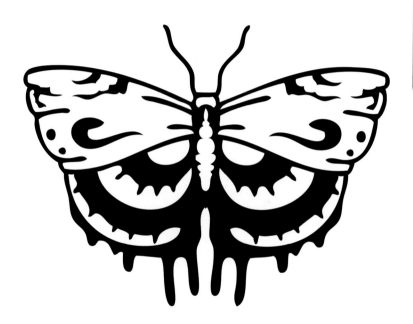

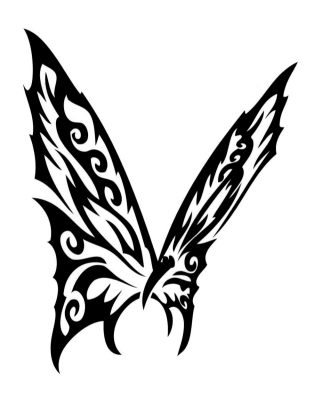

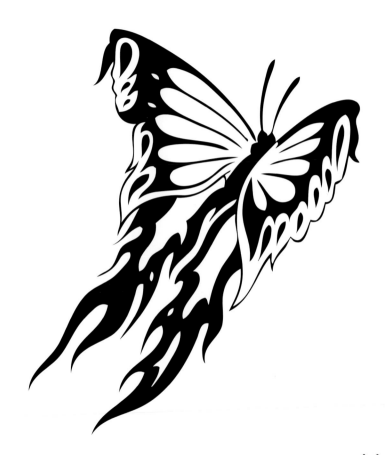

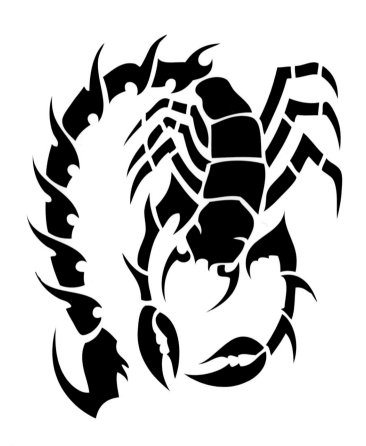

106 · Tattoo U

110 · Tattoo U

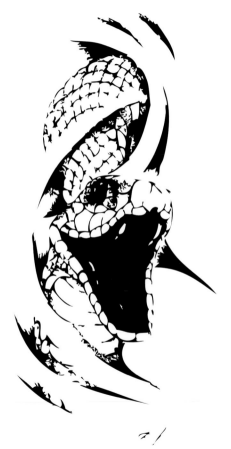

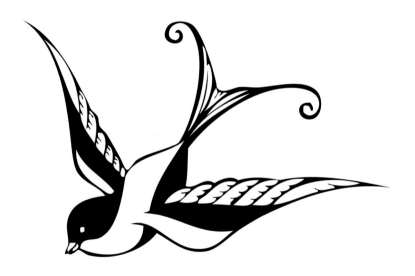

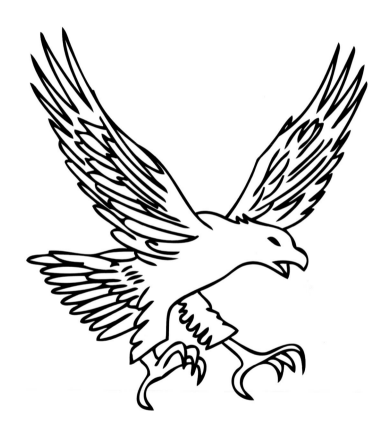

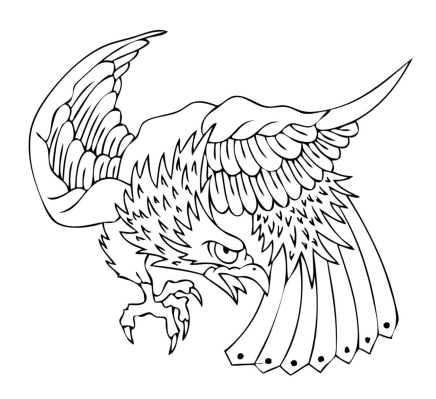

120 · Tattoo U

122 • Tattoo U

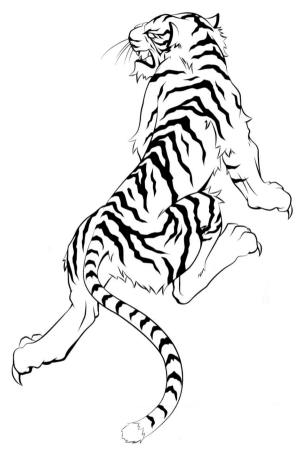

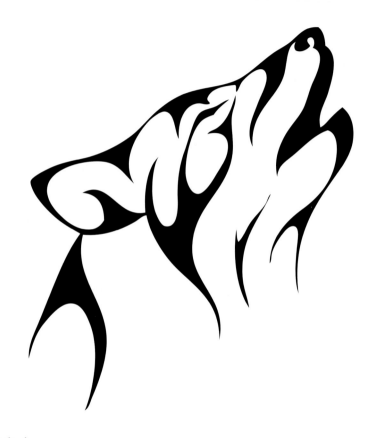

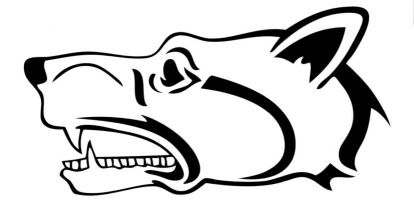

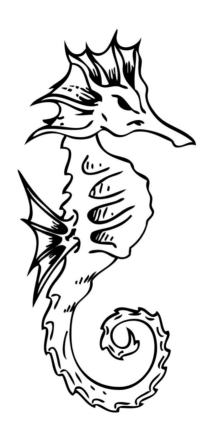

126 · Tattoo U

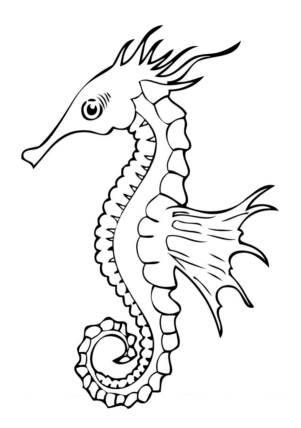

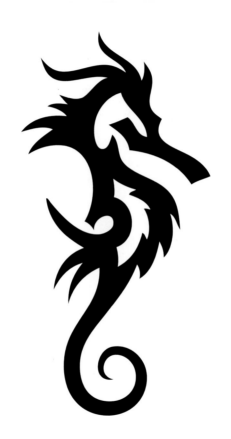

128 · Tattoo U

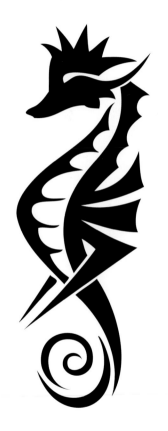

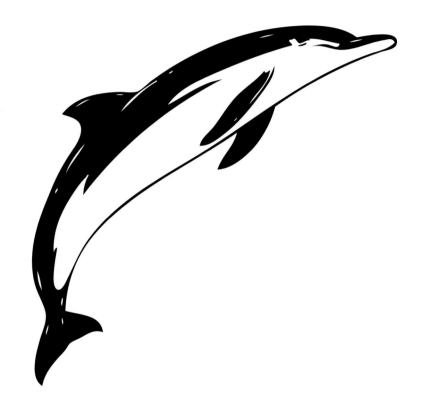

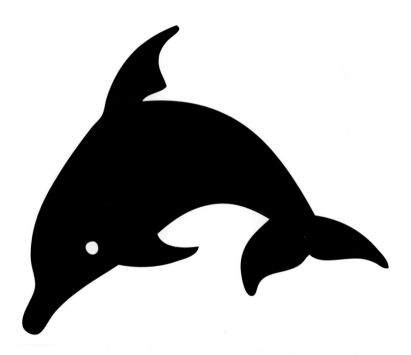

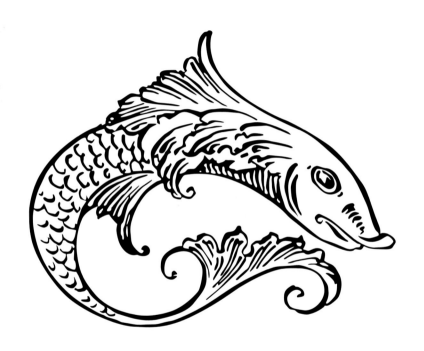

132 · Tattoo U

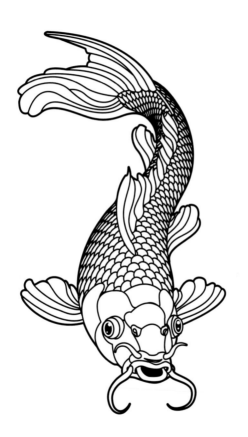

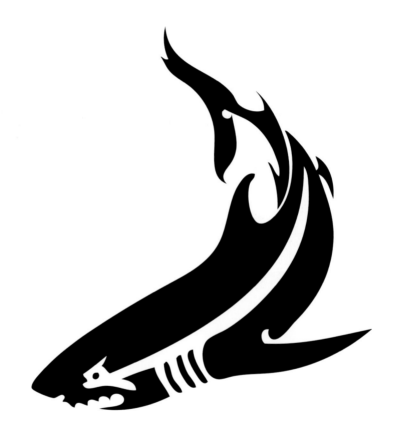

134 · Tattoo U

Tattoo U • **137**

138 · Tattoo U

Flowers

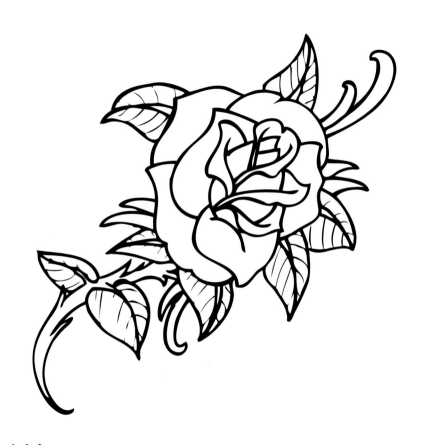

140 · Tattoo U

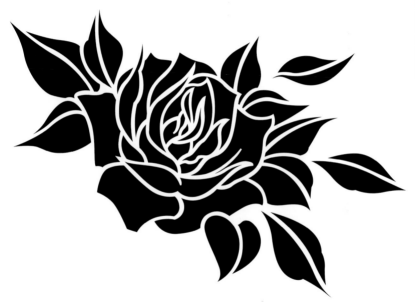

Tattoo U · **141**

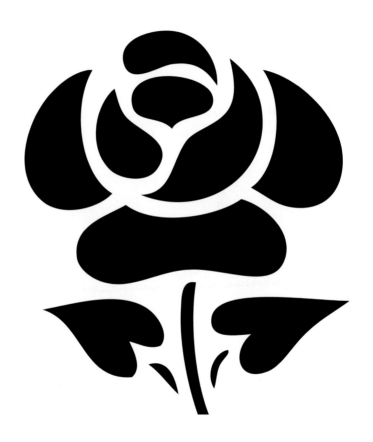

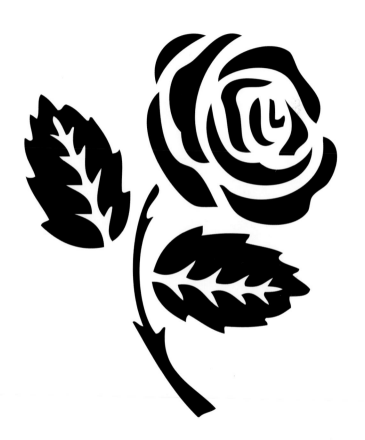

144 · Tattoo U

146 · Tattoo U

148 · Tattoo U

Tattoo U · **151**

152 · Tattoo U

154 · Tattoo U

156 · Tattoo U

Tattoo U • 157

158 · Tattoo U

160 · Tattoo U

162 · Tattoo U

164 · Tattoo U

166 · Tattoo U

170 · Tattoo U

172 · Tattoo U

174 · Tattoo U

176 · Tattoo U

178 · Tattoo U

182 · Tattoo U

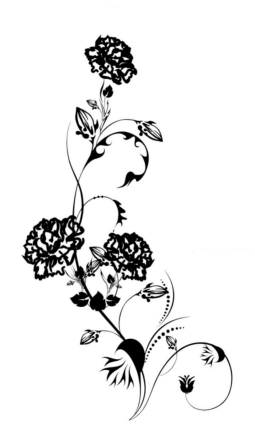

184 · Tattoo U

Hearts

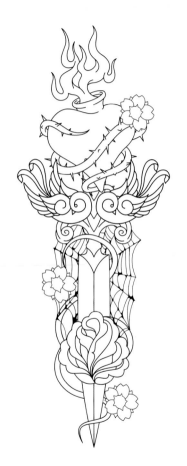

186 · Tattoo U

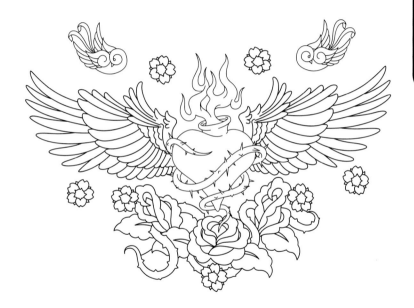

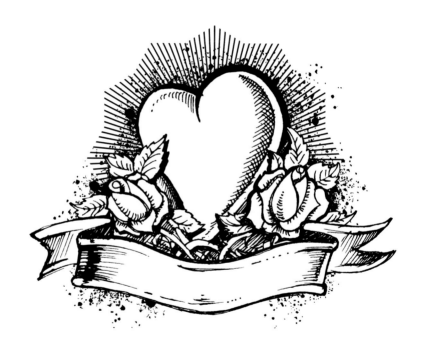

190 · Tattoo U

192 • Tattoo U

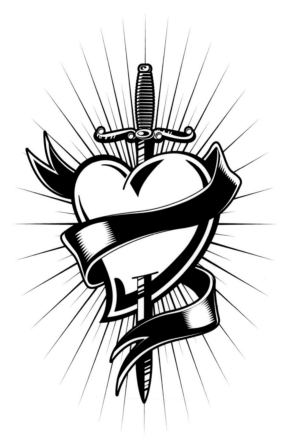

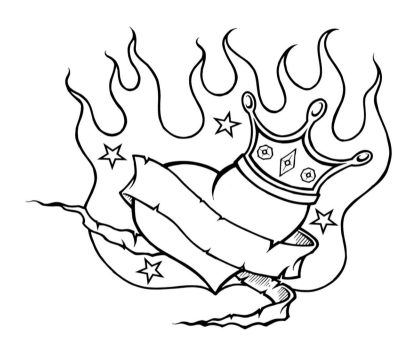

194 · Tattoo U

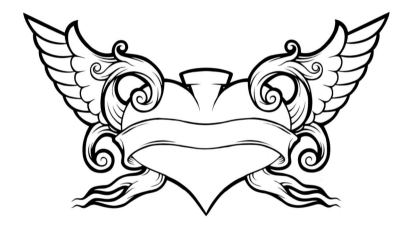

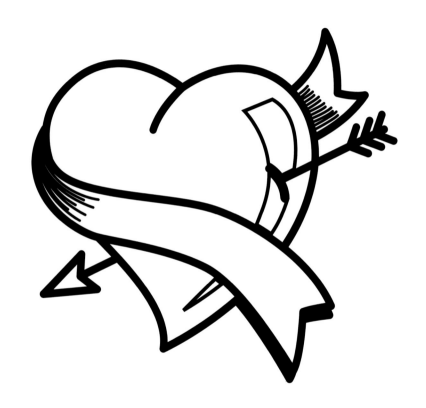

196 · Tattoo U

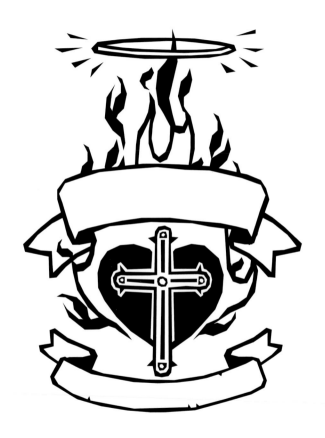

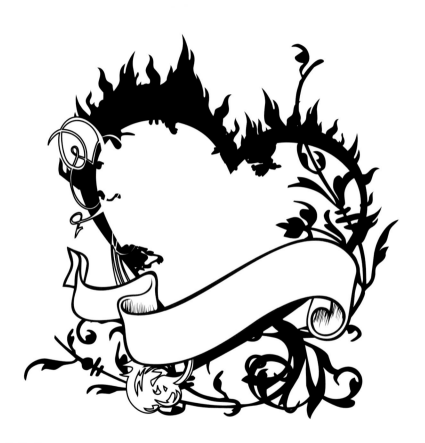

198 · Tattoo U

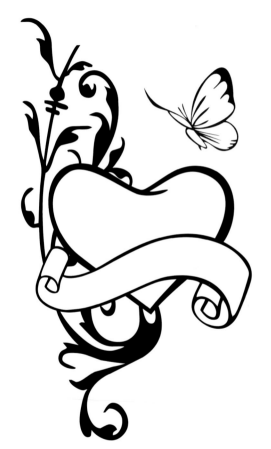

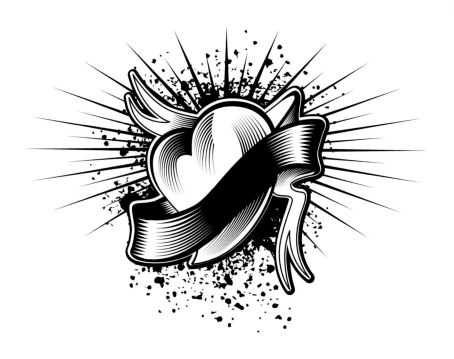

200 · Tattoo U

Tattoo U · 203

204 · Tattoo U

206 · Tattoo U

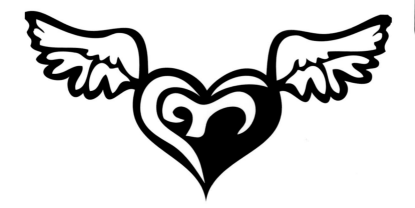

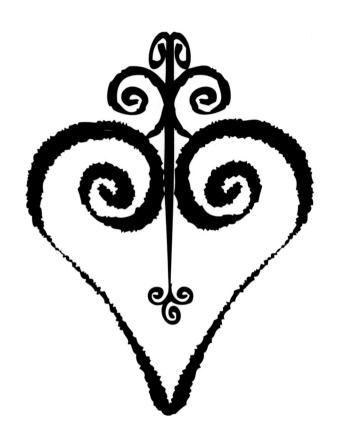

210 · Tattoo U

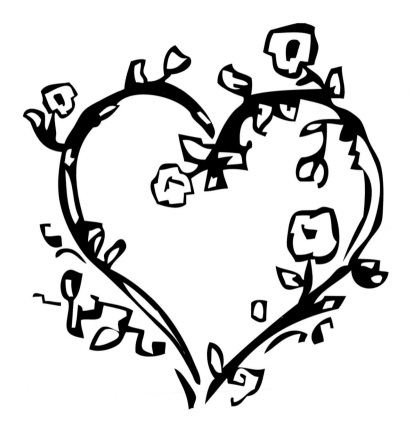

220 · Tattoo U

222 · Tattoo U

224 · Tattoo U

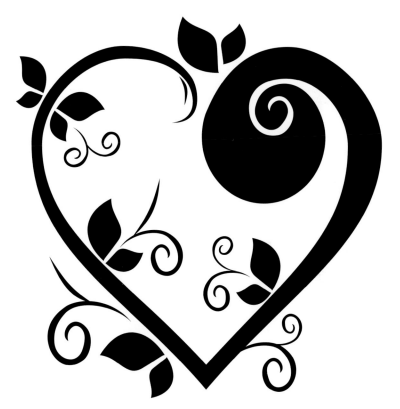

Tattoo U · **225**

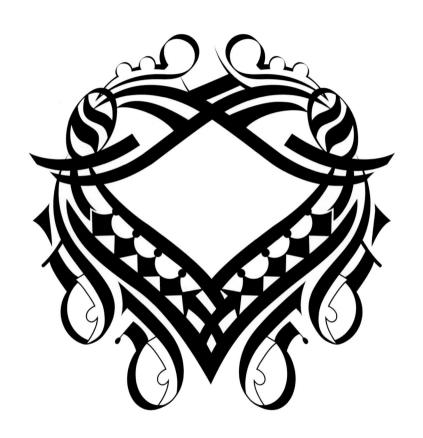

226 · Tattoo U

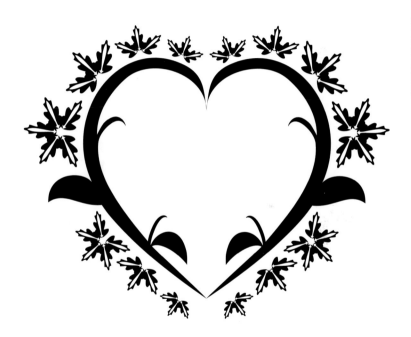

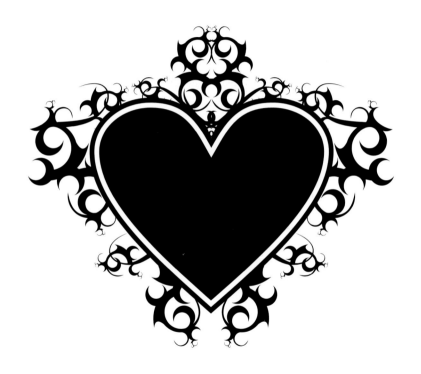

228 · Tattoo U

Tattoo U · **229**

230 · Tattoo U

Fantasy

232 · Tattoo U

Tattoo U · **233**

234 · Tattoo U

236 · Tattoo U

Tattoo U · **237**

238 · Tattoo U

Tattoo U · **239**

240 · Tattoo U

Tattoo U · **241**

242 · Tattoo U

246 · Tattoo U

248 · Tattoo U

250 · Tattoo U

252 · Tattoo U

Tattoo U · **253**

254 · Tattoo U

Tattoo U • 255

256 · Tattoo U

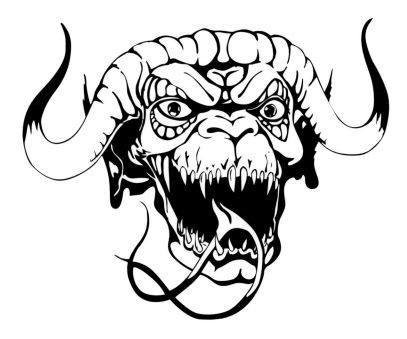

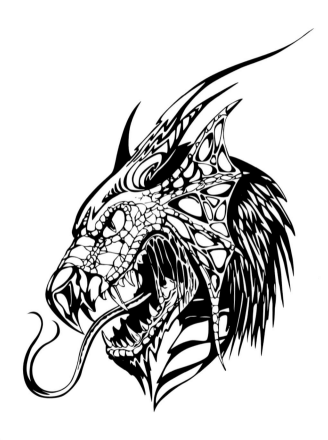

258 · Tattoo U

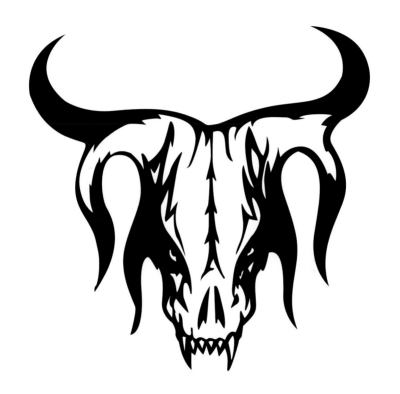

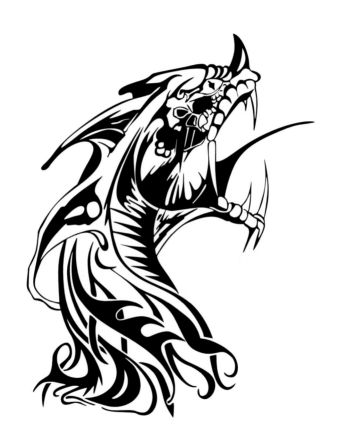

260 • Tattoo U

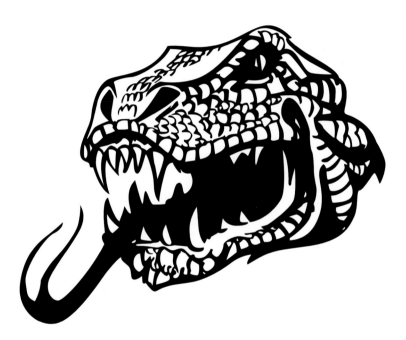

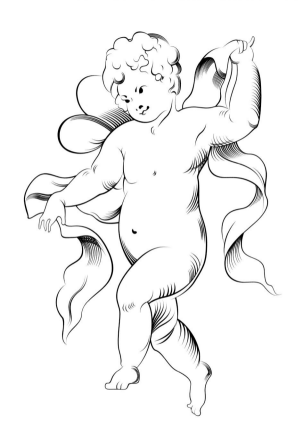

262 · Tattoo U

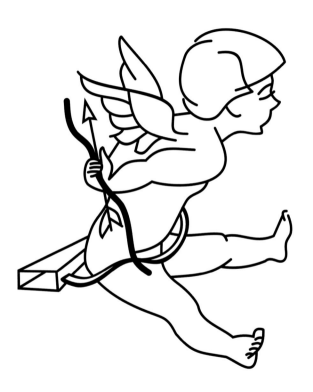

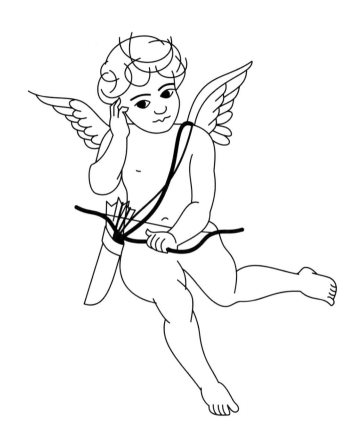

264 · Tattoo U

266 · Tattoo U

268 · Tattoo U

Tattoo U · 269

270 · Tattoo U

Tattoo U • **273**

276 · Tattoo U

Armbands

280 · Tattoo U

282 · Tattoo U

Tattoo U · **283**

284 · Tattoo U

286 · Tattoo U

288 · Tattoo U

Tattoo U • **289**

292 • Tattoo U

Tattoo U • **293**

294 · Tattoo U

296 · Tattoo U

298 · Tattoo U

302 · Tattoo U

306 · Tattoo U

308 · Tattoo U

310 · Tattoo U

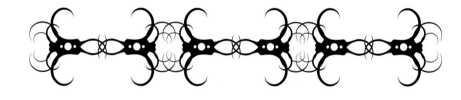

316 · Tattoo U

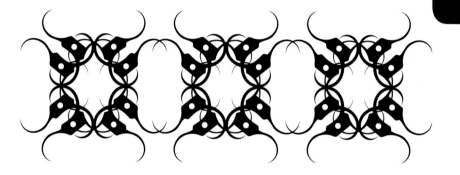

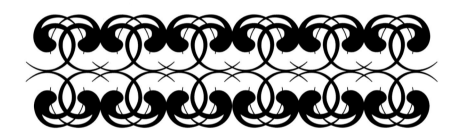

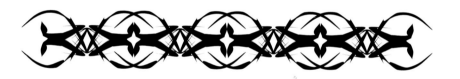

320 · Tattoo U

322 · Tattoo U

Asian Inspired

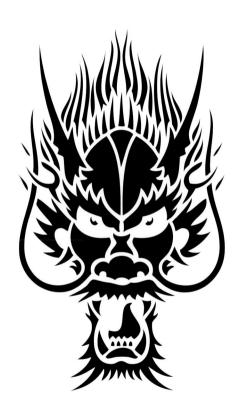

324 · Tattoo U

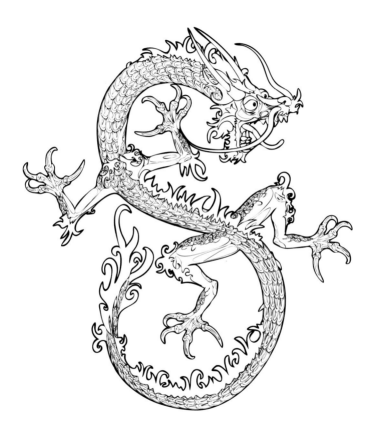

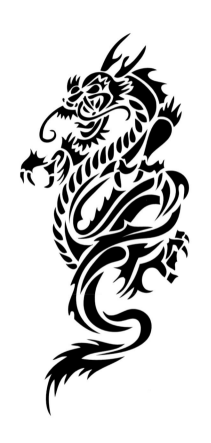

326 · Tattoo U

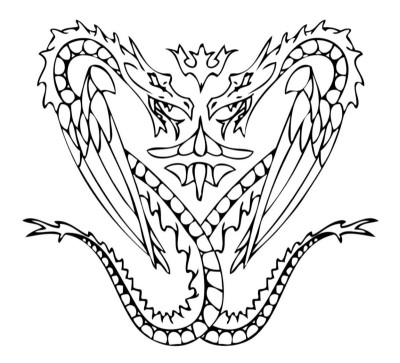

Tattoo U · **327**

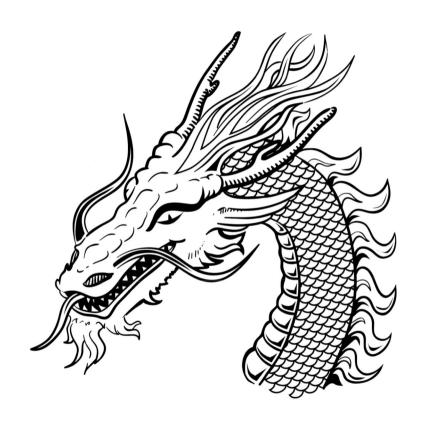

328 · Tattoo U

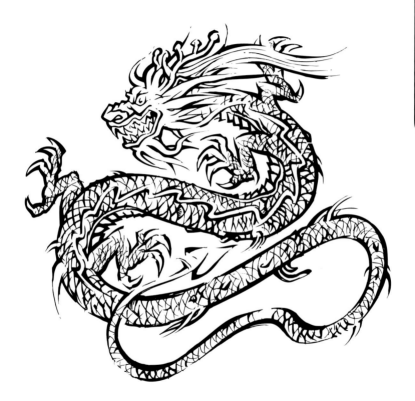

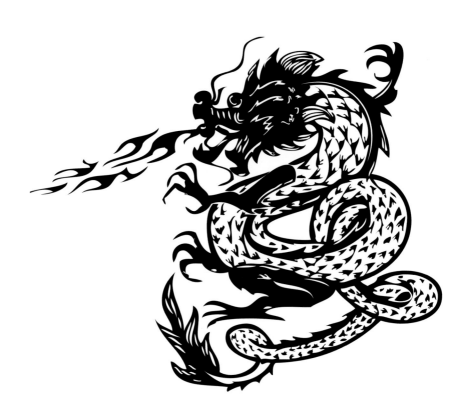

330 • Tattoo U

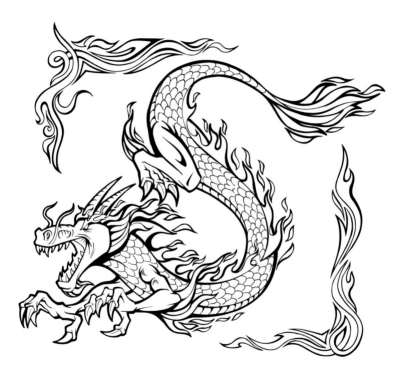

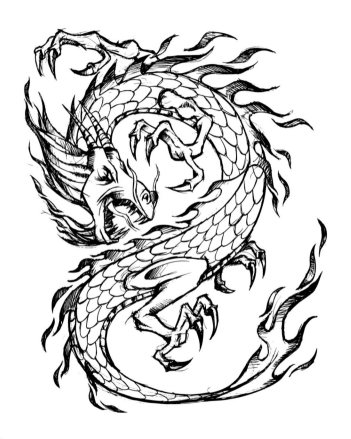

332 · Tattoo U

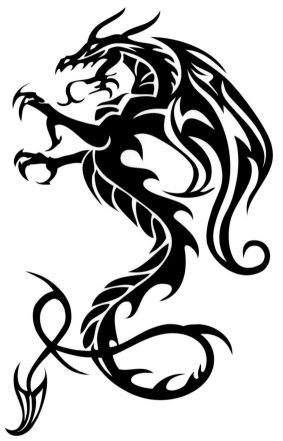

Tattoo U • **333**

334 · Tattoo U

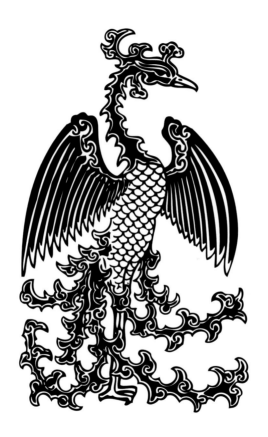

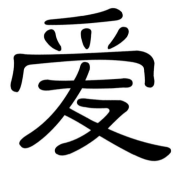

LOVE

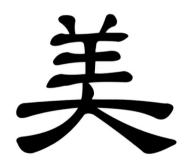

BEAUTIFUL

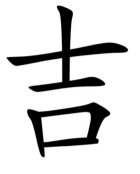

LUCK

VIRTUE

WEALTH

HAPPINESS

338 • Tattoo U

PROSPERITY

LONGEVITY

GOOD LUCK

HARMONIOUS

340 · Tattoo U

PEACE

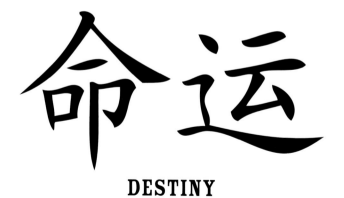

DESTINY

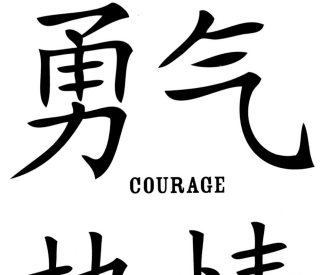

勇气

COURAGE

热情

PASSION

希望

HOPE

变化

CHANGE

友谊

FRIENDSHIP

真相

TRUTH

力量

STRENGTH

智慧

WISDOM

346 · Tattoo U

Tattoo U • 347

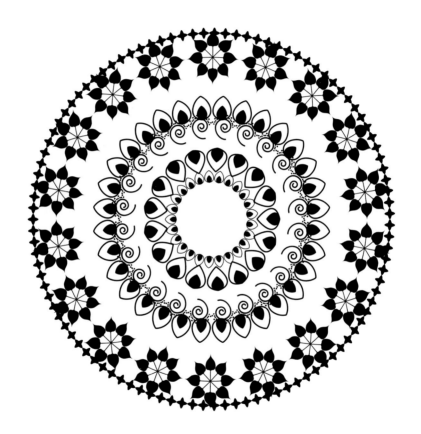

348 · Tattoo U

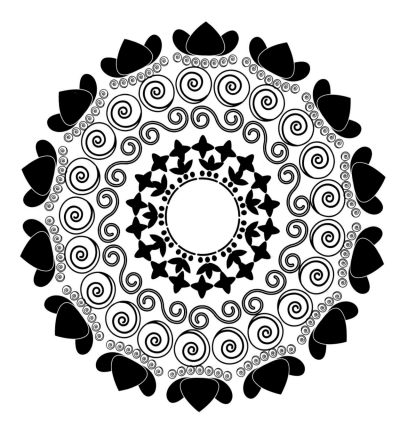

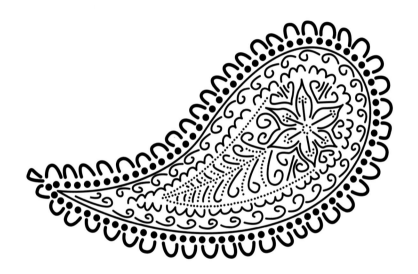

350 · Tattoo U

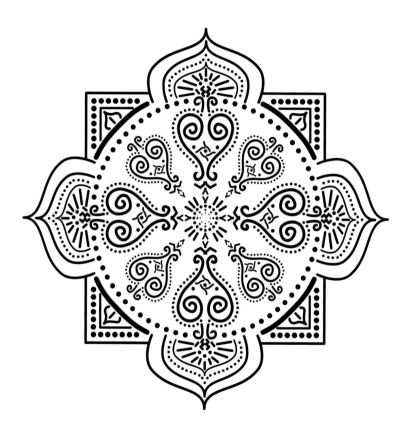

Tattoo U · **351**

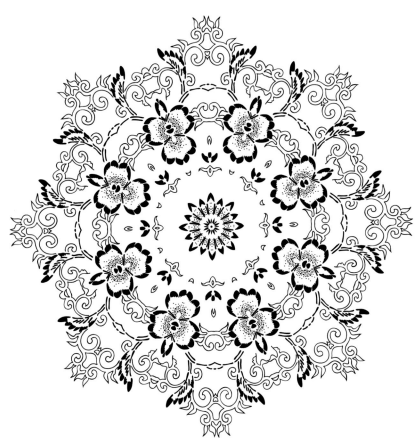

352 · Tattoo U

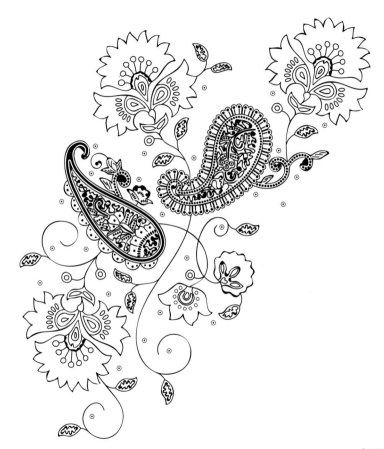

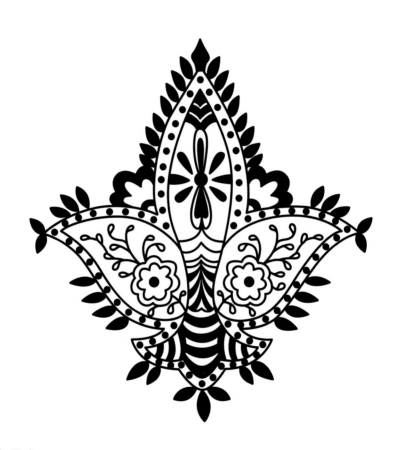

354 · Tattoo U

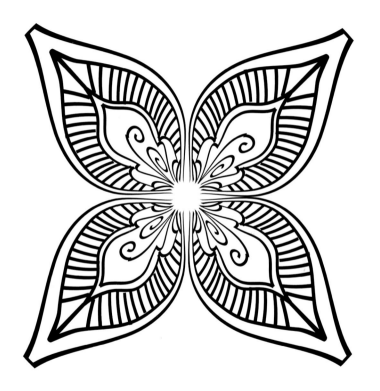

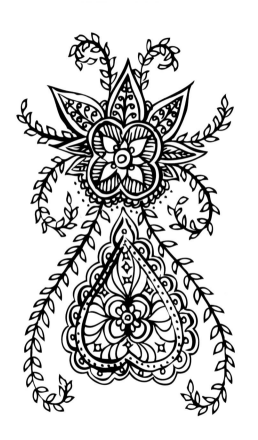

356 · Tattoo U

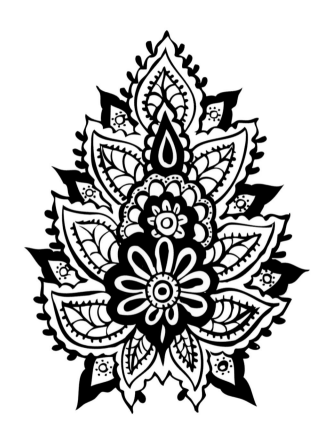

Tattoo U · 357

358 • Tattoo U

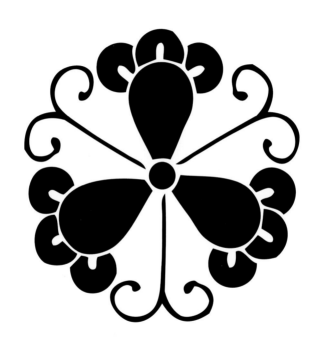

360 · Tattoo U

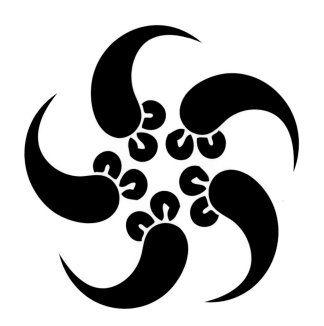

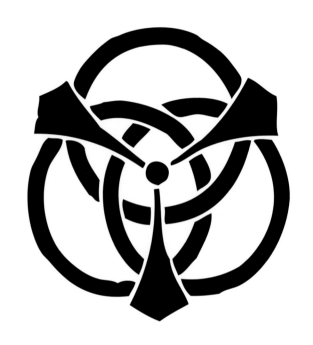

362 • Tattoo U

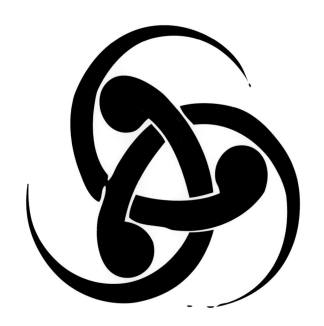

364 · Tattoo U

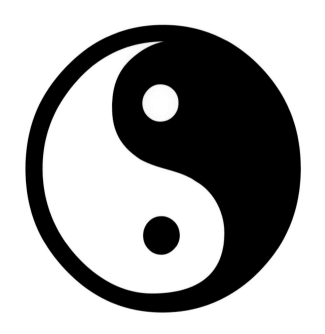

368 · Tattoo U

Letters

Tattoo U · **369**

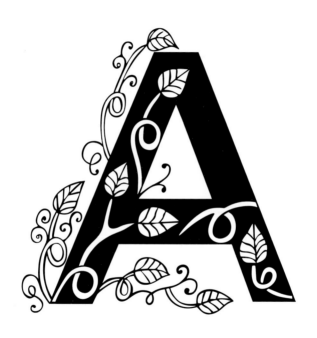

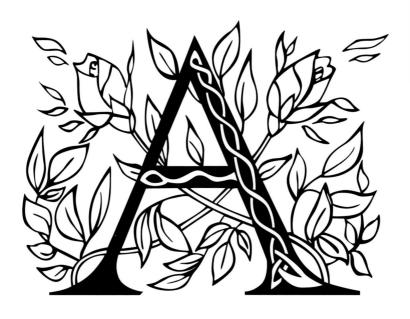

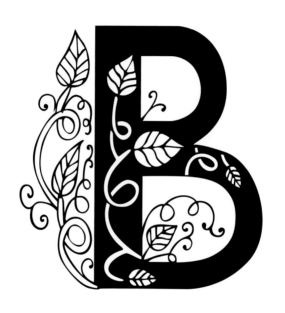

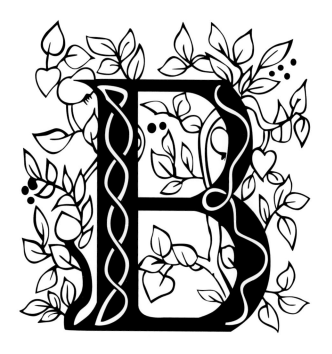

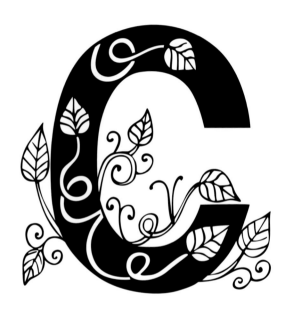

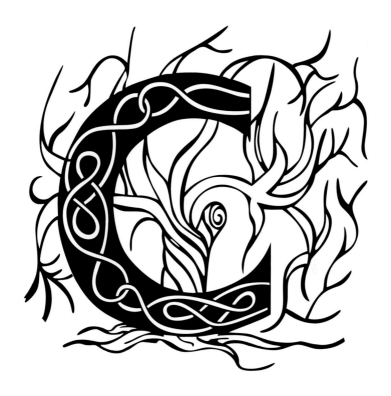

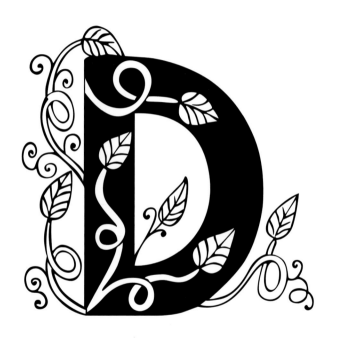

376 · Tattoo U

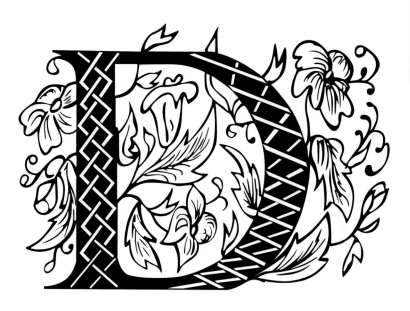

Tattoo U · **377**

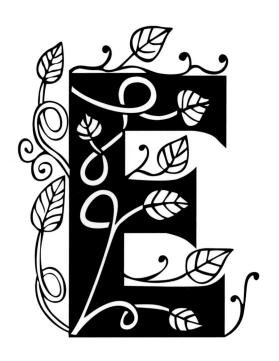

378 · Tattoo U

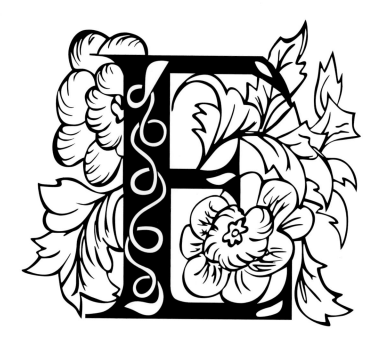

Tattoo U · **379**

380 · Tattoo U

382 · Tattoo U

Tattoo U · **383**

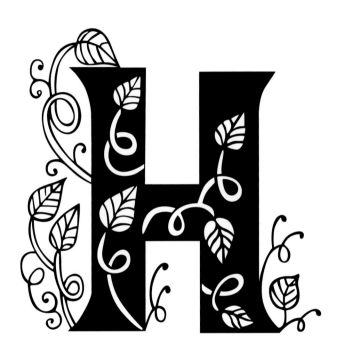

384 · Tattoo U

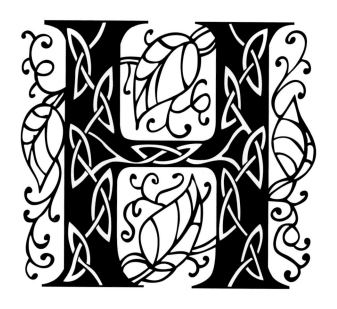

Tattoo U · **385**

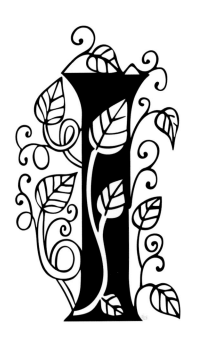

386 · Tattoo U

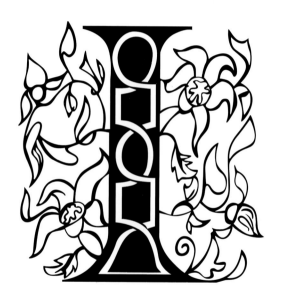

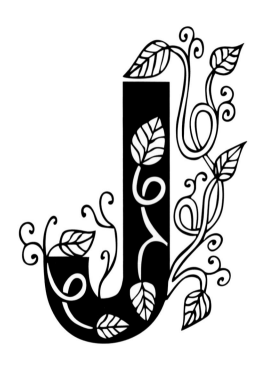

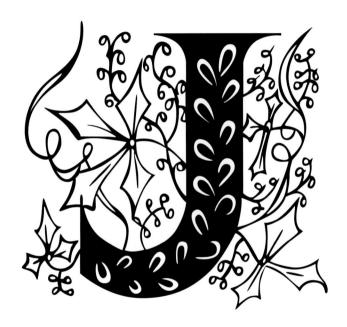

Tattoo U · **389**

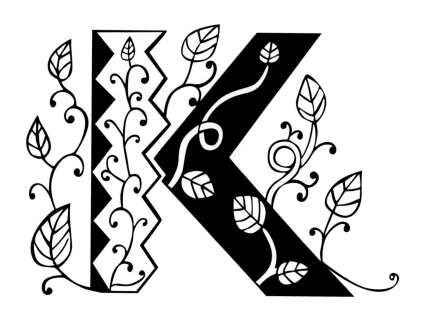

390 · Tattoo U

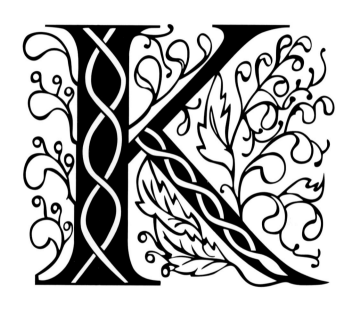

Tattoo U · 391

392 · Tattoo U

394 · Tattoo U

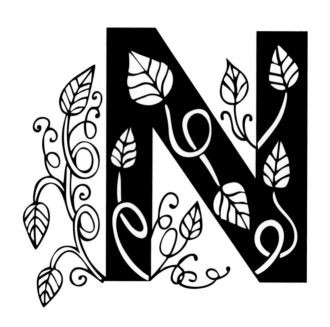

396 · Tattoo U

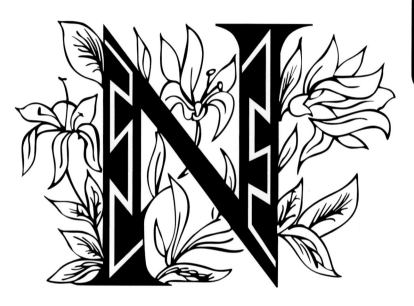

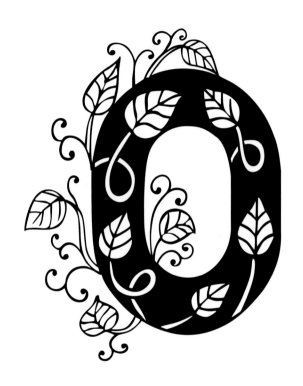

398 · Tattoo U

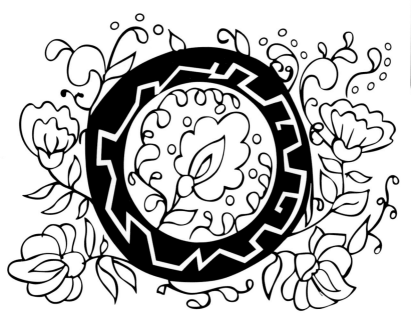

400 • Tattoo U

Tattoo U · 401

402 · Tattoo U

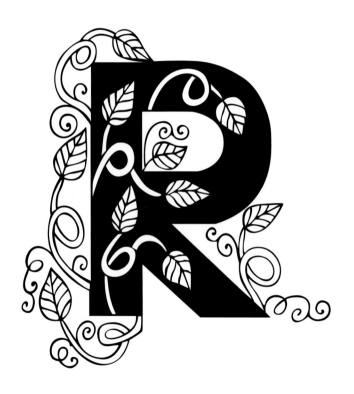

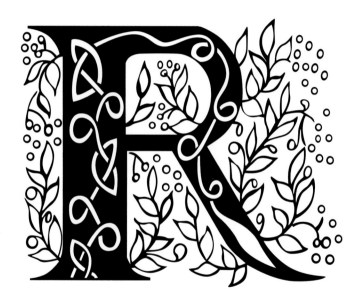

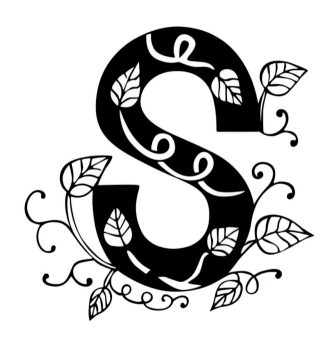

406 · Tattoo U

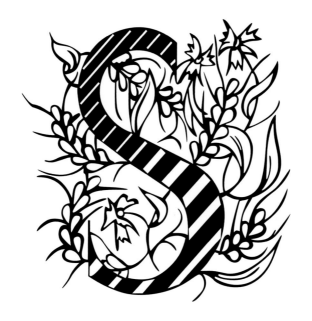

408 · Tattoo U

410 · Tattoo U

412 · Tattoo U

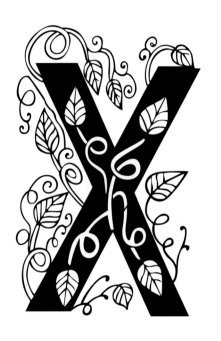

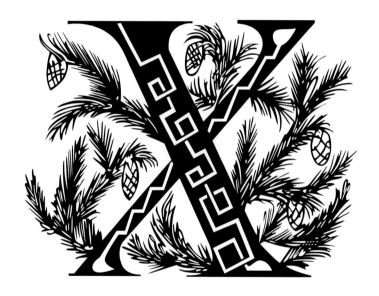

Tattoo U • **417**

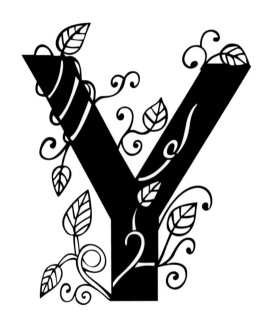

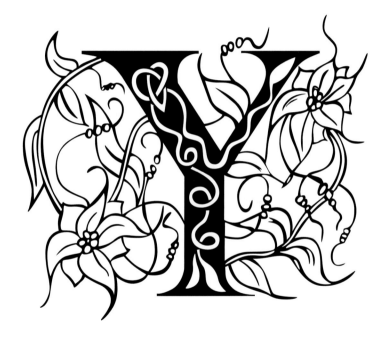

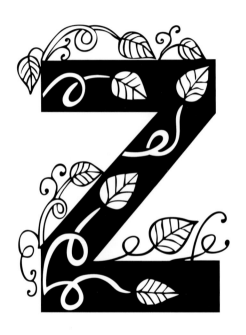

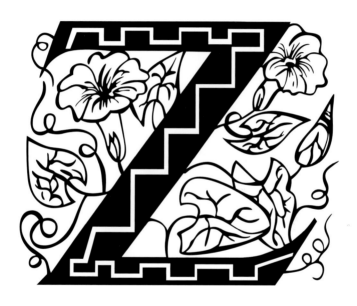

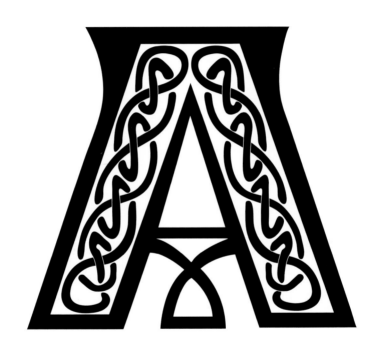

422 · Tattoo U

Skulls & Flames

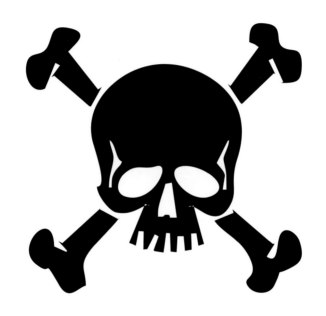

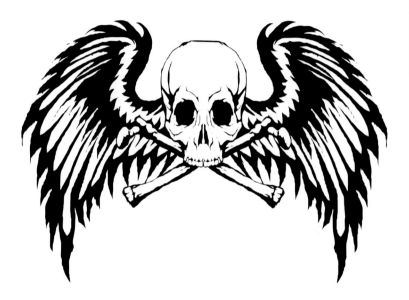

Tattoo U • 425

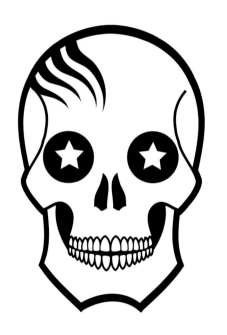

426 · Tattoo U

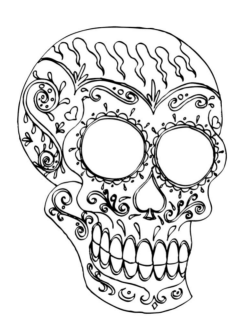

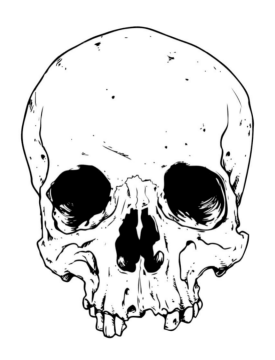

428 • Tattoo U

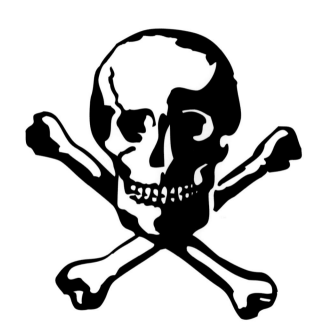

Tattoo U · 429

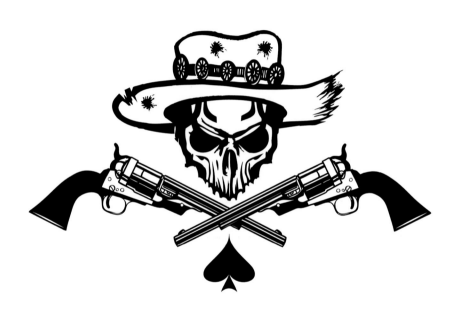

430 · Tattoo U

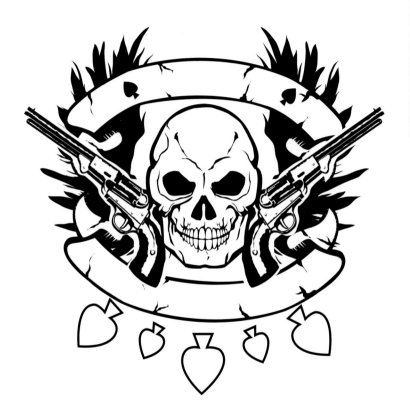

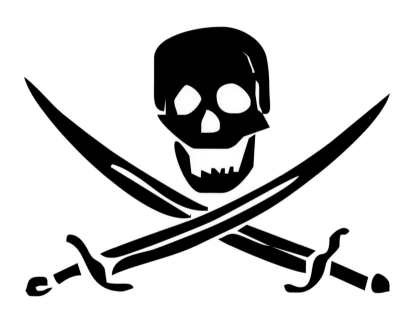

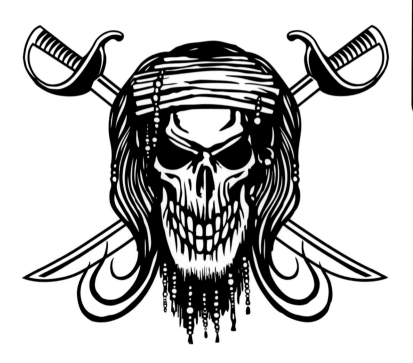

Tattoo U • **433**

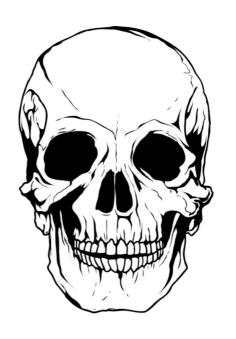

434 • Tattoo U

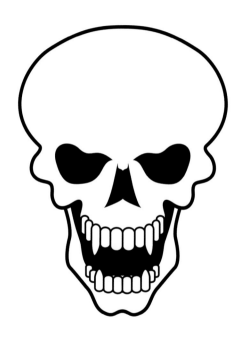

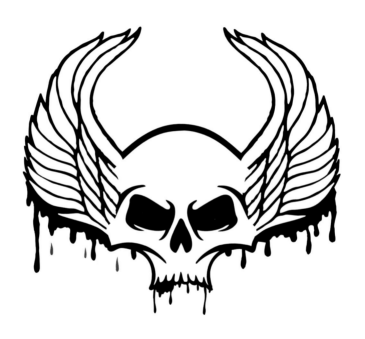

436 · Tattoo U

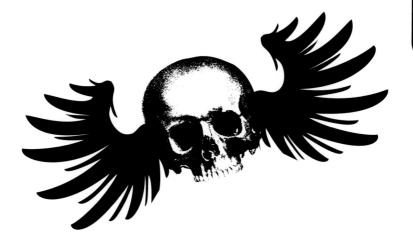

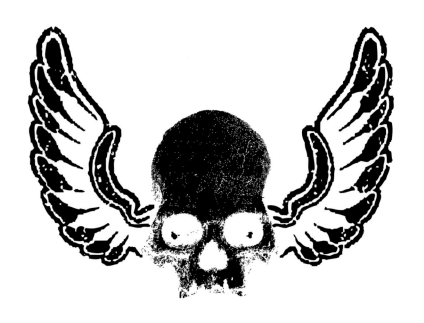

438 · Tattoo U

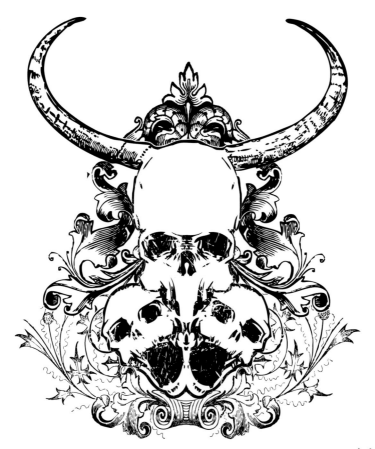

Tattoo U · 439

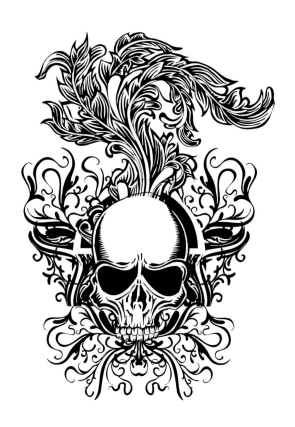

440 · Tattoo U

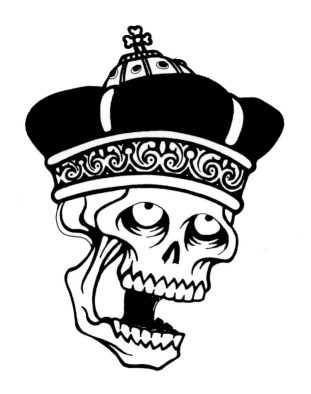

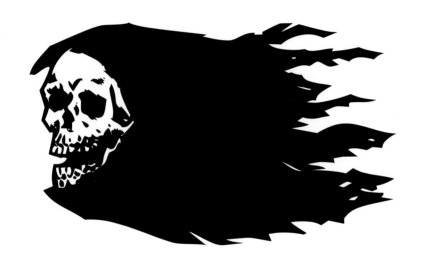

442 · Tattoo U

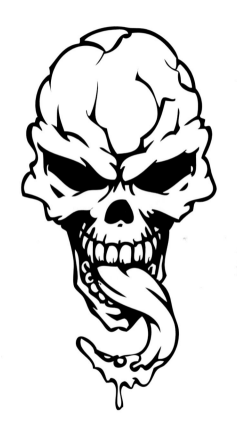

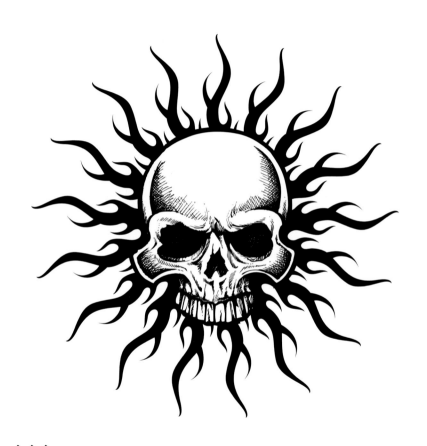

444 • Tattoo U

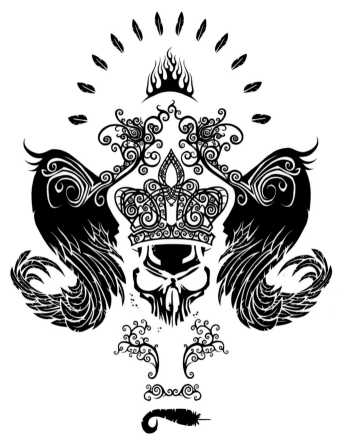

Skulls & Flames

Tattoo U · 445

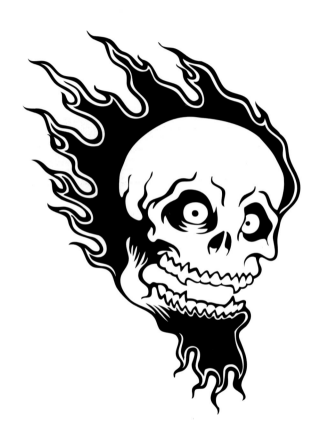

446 · Tattoo U

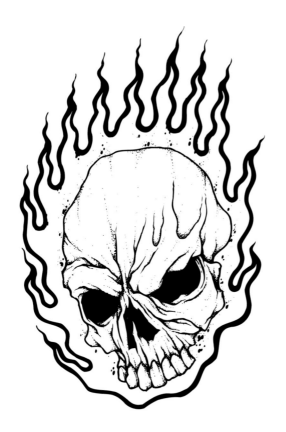

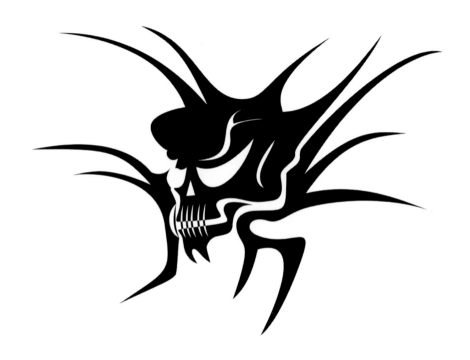

448 · Tattoo U

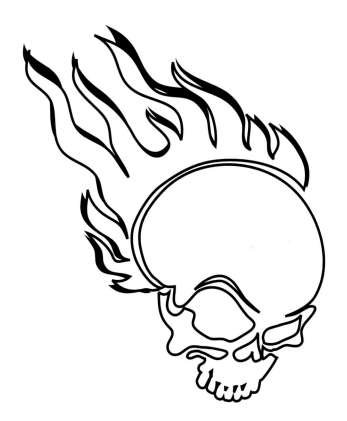

Tattoo U • 449

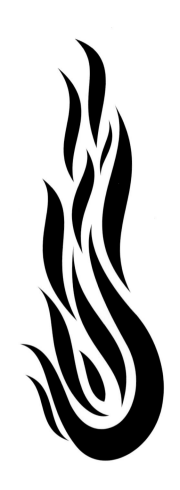

450 · Tattoo U

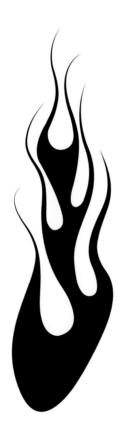

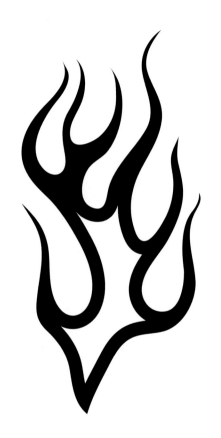

452 · Tattoo U

Tattoo U · **453**

454 · Tattoo U

Tattoo U · **455**

456 • Tattoo U

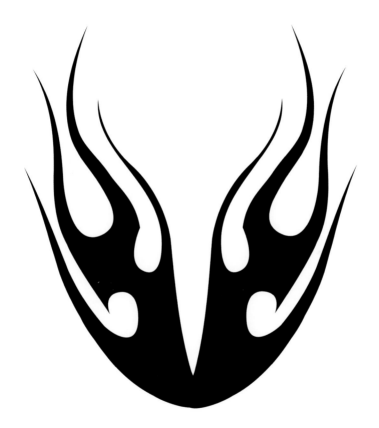

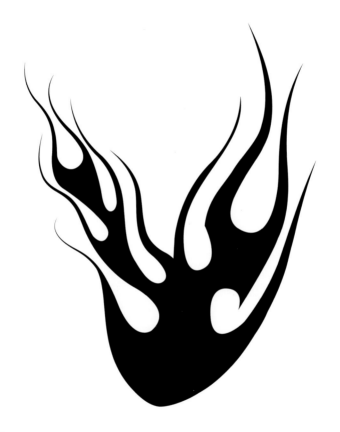

458 · Tattoo U

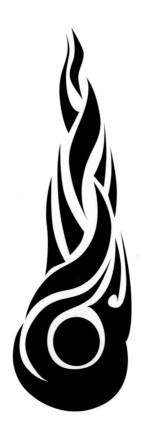

Tattoo U · **459**

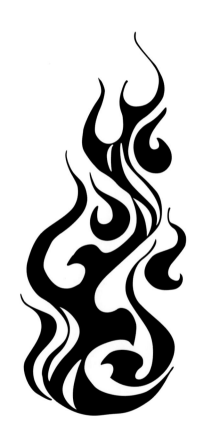

460 · Tattoo U

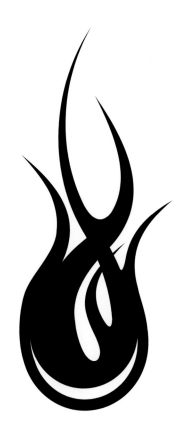

Tattoo U • **461**

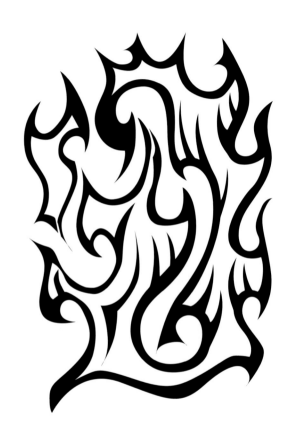

462 • Tattoo U

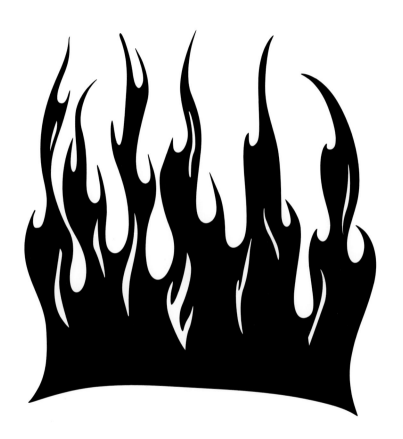

Tattoo U · **463**

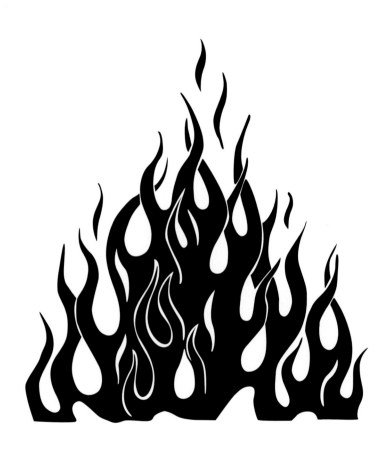

464 · Tattoo U

Skulls & Flames

Tattoo U · **465**

466 · Tattoo U

Nature Symbols

468 · Tattoo U

Tattoo U • **469**

470 · Tattoo U

Tattoo U • 471

474 · Tattoo U

Tattoo U • **475**

476 · Tattoo U

478 · Tattoo U

480 · Tattoo U

Tattoo U · **481**

482 · Tattoo U

Tattoo U · **483**

484 · Tattoo U

486 · Tattoo U

488 · Tattoo U

Tattoo U · 489

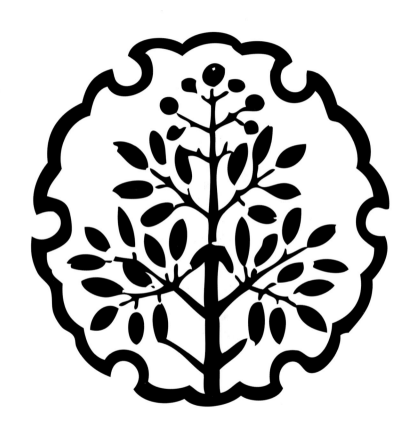

490 · Tattoo U

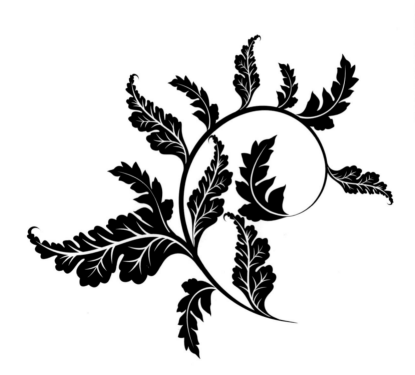

Tattoo U · **491**

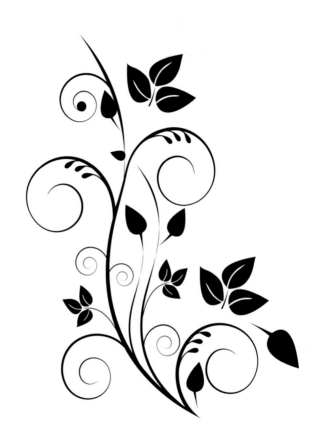

492 · Tattoo U

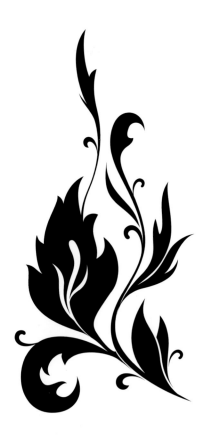

Tattoo U • **493**

494 · Tattoo U

Tattoo U · **495**

496 · Tattoo U

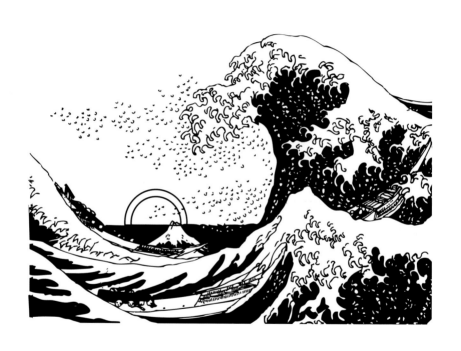

498 · Tattoo U

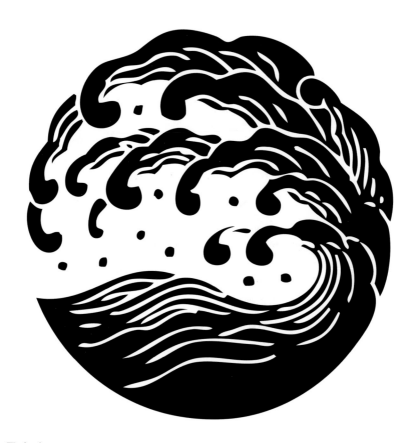

500 · Tattoo U

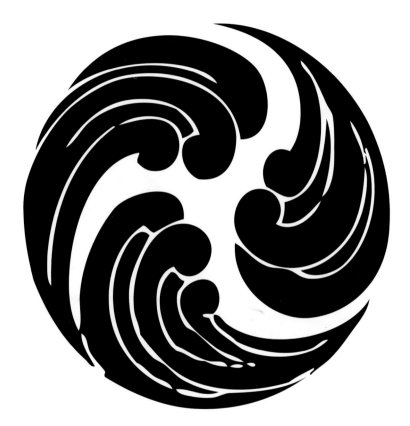

Tattoo U · 501

502 · Tattoo U

504 · Tattoo U